# A Letter to My Cat

NOTES TO OUR BEST FRIENDS

# A Letter to My Cat

## NOTES TO OUR BEST FRIENDS

CREATED BY LISA ERSPAMER

**CROWN**
ARCHETYPE

NEW YORK

Published in the United States by Crown Archetype, an imprint of the Crown Publishing Group, a division of Random House LLC, a Penguin Random House Company, New York. www.crownpublishing.com

Crown Archetype and colophon is a registered trademark of Random House LLC.

Grateful acknowledgment is made to Richard Jones for permission to reprint excerpts from "Velouria" by Black Francis, as performed by the Pixies. Reprinted by permission.

Library of Congress Cataloging-in-Publication Data is available upon request.

ISBN 978-0-8041-3965-6
eBook ISBN 978-0-8041-3966-3

Printed in China

Jacket design by Nupoor Gordon
Jacket photographs by Susan Weingartner
Endpaper photographs: Sharon Hardy (front); Susan Weingartner (back)

10 9 8 7 6 5 4 3 2 1

First Edition

A true cat lover cradles a new kitten and knows that nine lives will never be nearly enough.

—ANONYMOUS

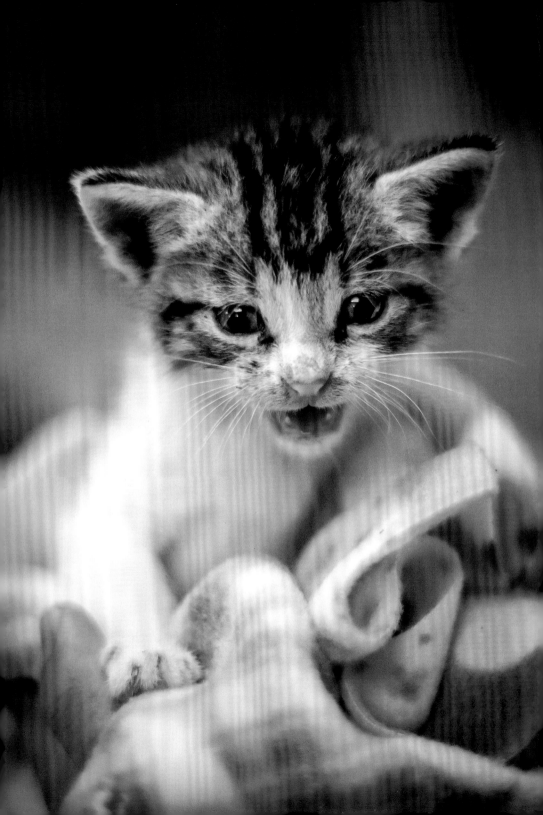

# Introduction

I am a lover of all things furry, and that is where this book comes in.

As a dog lover and dog mom, I am passionate about sharing my feelings for my four-legged family members. I wondered for a long time if they could understand . . . I mean *really* understand . . . how much I love them. And I figured if I felt this way, other people might too. So I decided to create a book called *A Letter to My Dog* with my friends Kimi Culp and Robin Layton. It was a hit! The sweetness an d joy that was shared in the letters between people and their canine companions was overwhelming.

As a cat lover and someone who was once owned by a couple of very fluffy kittens, I knew I wanted to do a second book for all of my feline-loving friends. So my team and I have spent the last year reading letters from cat people all across the country and even some from other parts of the world. We know this collection will capture the heart of anyone who has ever loved or been loved by one of these frisky little furballs.

*A Letter to My Cat* celebrates a special type of creature . . . one of soft fur, gentle purrs, rough licks, maddening independence, playful pounces, and— let's be honest—odd demands. Not all cats need fresh water from the kitchen tap at four in the morning, but *only* cats need it. Cats will find a way to get to the highest possible perch, and if that means jumping onto the kitchen counter and scampering across the stove to get on top of the refrigerator, then so be it. They have secret hiding places all over the house, and nothing is off-limits, especially your favorite black sweater. And when they ask you to pet their belly, it doesn't mean you won't get swiped by a claw if you're not careful. Cats show their love for us in unusual ways: rubbing their scent all over our bodies, kneading our bellies with their perfect paws, or . . . the highest form of affection . . . leaving a dead bird on our doorstep. Sometimes aloof, always mysterious, cats are ever willing to remind us that there is nothing more important in life than a relaxing catnap in the sun.

*A Letter to My Cat* honors the fantastic feline companions who grace our lives with their regal presence. My hope is that this book conveys the magical and transformative love of a pet and inspires people to adopt. There are millions of kittens who are in need of forever homes; maybe one of their nine lives can be spent with you.

-*Lisa*

The Letters

Dear Luna,

Zoe found you at a shelter when she was six. I had just gotten divorced from her dad, John. So there you were, a comforting little ball of black and white fur. It was Christmastime and she went to stay with her dad. You were sick and very tiny. We stayed in bed together and slept the day away.

Years passed, and many moves to new homes. You always adapted and followed Zoe everywhere and slept with her all of these years, until she went to college this past fall. Now you and I comfort each other. Empty-nest syndrome is hard for us both.

You are a great cat. And I love you.

Love,
Rosanna

*Dear Colonel Meow,*

Why me? Why did you choose me?

Yes, I adopted you. And yes, I picked you up and took you home. But you and I both know I had no choice. One look at those eyes and obedience is the only option.

But why me? Why did you choose me?

Is it because you *knew* I would feed you any time you begged? Since I have no discipline with myself, you *knew* you could probably prey on my bad habits. Every time you meow, I respond with "Maybe he's hungry?" I'm guessing you've read about Pavlov's dog experiment. And trust. You've trained me well.

But why me?

Is it because I'd let you have any space in the house? The couch, yours. The kitchen table, yours. Any spot on my bed, it's yours. I'll just sleep in an awkward position so as not to disturb your slumber. No sir, please, don't get up; you've had a long day. Even the bathroom. Take it. I don't need privacy, honest. And your staring at me actually helps. Gets me moving along. No sense lounging about, we've gotta feed you soon.

But why me?

Maybe it's because you knew I would lavish you with gifts. Somehow I became all three of the wise men. But instead of gold, frankincense, and myrrh, I've showered you with toys, treaties, and catnip. All of these things are probably legitimate reasons and all make valid arguments. But the thing is, I don't have to know why you chose me, I'm just happy you did. And even though I've tried to give you everything I can think of, there's one thing you've given me that I didn't know I could get back. My dream. Because of you I allowed myself to create again.

And that, my friend, is bigger than any spot on the bed.

Thank you.

*Forever yours,*
*Slave Beast*

**Tony Azevedo:** *Snow*

Dear Snow,

Shortly after the first time I met you, you hid in a water pipe under the sink in our bathroom and gave us a heart attack until I was finally able to lure you out with bacon.

You once tried to pounce on a fish dangling from a fishing rod but instead got your mouth stuck on the hook and had to be rushed to the vet.

Every time we fly together, you meow the entire flight in disbelief that you have to sit underneath my seat instead of having a first-class seat of your own.

Water in a bowl does not suffice, so you demand fresh running water from the faucet.

You meow and try to eat everything we eat but either refuse it or get sick if we actually offer it to you.

You drink out of my water glass at night and on many occasions knock it over onto my face at 2 a.m.

You also climb over my face continuously throughout the night in search of the most comfortable spot on the entire bed.

You treat the litter box like a sandbox and seem to throw most of the litter onto the floor.

But in the end you are my precious little Snow Snow; you bring me a great deal of happiness, and I will love you forever.

Tony

**Ellie Barancik:** *Francis and Ollie*

*Dear Francis and Ollie,*

How many times have you heard this: "Oh my God, they're huge." That's always the first thing to come out of people's mouths when they meet you both. And my answer (which you must be tired of hearing after twelve years) is always, "Yes, they're big boned—twenty and eighteen pounds of pure love." The next thing to come out of their mouths is always, "Wow, they're beautiful. They look just like tigers." And I very proudly say, "Well, they *are* third-generation Bengal." "Ohhhhhh, Bengals!" they all coo. And as you both vie for attention via your sweet yet slightly aggressive head butts, the next thing said is always, "And so friendly!" Now I beam with pride as the focus is no longer your girth, but instead your awesome, sweet, and weirdo personalities.

Sure, there are times when I get annoyed with you both, usually around feeding time. Ollie, when you were little, you used to let me know it was time to wake up by jumping up on my nightstand and very methodically taking your right paw and finding the perfect thing to swipe off the table—nothing was too small, too big, or too loud for you to swipe.

Francis, you don't take "no" for an answer either. No matter how sleepy or busy I am, when that paw of yours continually taps me on my leg or arm, I know you mean business. If I were to decode the taps, they would read like "Me. Me. Me. When I finally get up, you bolt into the kitchen, making that chirpy meow reminiscent of Curly from the Three Stooges: "Woo woo woo woo!"

I'm going to be really honest with you guys. I often dream about a life without massive amounts of cat hair. A life without hauling a twenty-pound sack of Tidy Cats into my house. A life without finding dismembered dust-covered furry toy mice in the strangest of places (my boot). A life without being woken up in the middle of the night by the sound of a hairball about to make its debut into the world and onto my carpet. A life where I don't have to contort myself around you big-boned bundles of love in *my* bed because I don't want to disturb *you*. Yes, that life sounds so nice, but then I cup those faces in my hands, look into those green eyes, and say, "What would I ever do without you?? You—little—*babies*."

xo,
Ellie

**Erica Berse:** *Jill*

*Dear Jill,*

You've always been a survivor. Found abandoned at two days old, you were bottle-fed and brought up to be the sweet little baby you still are eight years later. Since you came into my life, you've always been my little baby girl, so sweet, loving, and affectionate.

When you were diagnosed with osteosarcoma last year, I didn't think I would survive it. How could you have cancer? How could God be so cruel to you? I cried into your fur for hours when we got that diagnosis, but all you did was purr and beg for belly rubs. You didn't know you were sick. You didn't know what a long road you had ahead.

This past year you have endured so much. You had a severe operation where your leg was taken from you and you didn't know why. You faced chemotherapy, blood tests, and X-rays. Yet through it all, you were *my* strength. You hop along on three legs as if nothing has changed. Smiles and tears are brought to my eyes on every single visit to the vet when people say, "That kitty can't be sick!" because you've shown courage, perseverance, and cheerfulness throughout this whole ordeal.

Little Jill, you are my hero. I don't know where the rest of this journey will take us, but I know my life has been enriched by having you in it. You will forever be my sweet little baby who begs for belly rubs and purrs louder than a lion.

Thank you for teaching me what real strength and bravery look like. Thank you for showing me that love is unconditional. Thank you for your wet nose and your kisses.

*I love you forever.*
*Mommy*

*From me to BUB:*

*Dear BUB,*

It's me. Mike. You know, the guy who spends all day with you and rubs your belly to get you to pee in the litter box. I know it's weird for me to be writing you a letter since you can't read English, and we communicate telepathically anyway, but it's for a book so that other people can read it too. Which is also weird.

Anyway, I just wanted to let you know that I'm forever grateful to you for picking me to be your sidekick in this crazy adventure you're on. You could have summoned anyone to take care of you after you crash-landed your space pod onto Earth—but you picked me. I really didn't know what I was getting myself into when I took you home, but I now realize that your mission is very important, and I'm happy to help you bring joy to millions of people every day. This is the coolest job I've ever had, and I didn't even apply for it. And you're the best boss a dude could ever hope to have.

I'm also grateful to you for really bringing the best out of me. Thanks to you I've learned so much about good animal care, about compassion, about what it means to care for someone more than myself, and, most surprisingly, about how to talk in front of large groups of people without feeling like I'm going to throw up.

I imagine that from the outside looking in, having a super-famous cat must seem totally bizarre. But to my family, our friends, and me you're just a really great cat that has magical powers. Wait, that's also bizarre. But true. GOOD JOB, BUB.

*Mike*

*From BUB to me:*

It's me. BUB. I think we make a great team. Please stop smoking.

Also, why are you typing out everything I am saying? I don't get it.

*BUB*

*To my darling Puddy:*

I once read in a newspaper article that cats could easily live without humans and just stick around because they like the lifestyle. If that is indeed true, I am really happy that you have decided to stick around me. You bring so much joy, entertainment, and comfort to my life.

You came into my life eighteen years ago, the very month that I moved to New York City. You were five weeks old and weighed only eighteen ounces. I lived in a ground-floor apartment on Twenty-fourth Street and had an extreme mouse problem. You developed into an excellent mouser and helped me keep my sanity! You even woke me up one night by bringing one of your conquests into bed with me. I screamed and tossed the covers—you and the mouse both went flying!

You have been with me through thick and thin and my entire life in NYC: three different apartments and many personal and career ups and downs.

Whenever I get home, you greet me at the door with a hearty meow and then look at me as if to say, "Okay—now feed me." I so very much enjoy your quirky personality, your cuddles and affection.

As I see you getting to be my "old man," I hope that you have enjoyed me as much as I have enjoyed and loved you. Puddy, you have brought so much to my life, and I have been honored to be a part of yours.

Thank you so much for choosing me to be the human you spend your life with. You are truly loved.

*Love, your mom,*
*Anne*

**Lauren Caltagirone:** *Harris and Austin*

Dearest Harris and Austin,

A wise man once said, "Cats are like potato chips—you can't have just one." Wait . . . either a wise man said that or I saw it stitched onto a pillow at Oma's house in Boca Raton.  Either way, I agree. I'm so grateful to have you both in my life.

You boys are as soft as clouds, and as fragrant as a thousand sunsets (your fur, that is—the stuff you do in the litter box is beyond human comprehension). And you're such sweet brothers—you enjoy grooming each other so much it's a good thing you're not blood relatives.

Thank you for having the most adorable faces—Instagram was invented for you. And thank you for the daily 4 a.m. circuit-training sessions, knocking over lamps and using my chest as a trampoline. I'm just happy you're staying fit.

Thank you for sleeping in bed with me every single night. I'm sorry I squirm sometimes. (Please come back to bed. I'm so cold.) Thank you for letting me pet you harder when I drink. And hey, I didn't want to mention it, but thank you for lending me money that one time.

Thank you, boys, for keeping me company in the bathroom while I straighten my hair, and most of all, thank you for helping me choose outfits for dates. I know the right guy won't mind a little cat hair on my dress, and that guy we shall call Daddy.

It's hard to remember a time when you weren't in my life, when I was just a single girl living in a studio apartment surviving on a diet of Lean Pockets and tequila, with no cats. I was incomplete. Now people look at me—two cats, two bedrooms, still a healthy dose of Lean Pockets and tequila—and think: She has it all . . . She has it all.

xoxo,
Mommy

**Gregory Castle:** *Bullfrog*

*Dear Bullfrog,*

Who exactly are you?

We've been together now for eight happy years, yet from the moment I first met you, held you, gazed at you . . . a twelve-week-old kitten rescued from a dumpster where you rooted for your next meal . . . I have pondered this question.

Now, as a mature adult, you are magnificent: handsome, dignified, and possessed of a placid majesty that never explains itself. And the question remains.

What are you thinking about as you sit with such serene composure on the bed, the couch, or the window ledge? What are you experiencing? What would you tell me if you could speak my language?

What worlds do you inhabit and explore? What do you do there?

You are a mystery. But that very mystery I find so engaging, so intriguing, so spiritual. As I marvel at you, I am lifted into a different world. A world of tranquility and wonder. You teach me that there is so much more, but for now, mine is not to reason why. I can be content with your magnificence, your devotion to me, and my love for you.

And I am.

*Gregory*

*Oh sweet Buddy,*

February 27, 2012, was just another Monday morning. I was in the office on the phone; Rick was in the kitchen getting coffee and starting his day. But, my precious Buddy, although my office door was closed, you sensed something was terribly wrong and began acting so unusual. You went nuts. You scratched at the door, scratched at me, and meowed frantically as you jumped on and off my lap. You were relentless in your tactics to get my attention. Fortunately, you did.

I picked you up to relocate you to the family room. It was then that I saw the top of Rick's head just beyond the kitchen countertop. I walked around the counter to find our Rick despondent and gasping for air. I didn't know it at the time, but Rick's heart had stopped.

Phone in hand, I immediately dialed 911, but within a matter of seconds and to my horror, Rick stopped breathing in my arms. When EMS arrived, they got Rick's heart to beat again.

Buddy, you are a true hero. Your actions that day not only saved Rick's life but continue to save more lives. Your story helped inspire the "Take Heart Orlando" initiative to train every Orlando citizen in CPR.

As we finish this letter, you are cuddled next to us. You, the once-wild thing, have learned to trust, love, and be loved. How can we thank you for all the memories that might not have been were it not for you? Our hearts are not big enough to contain the love we feel for you, those who came together to bring Rick back to us, and the gift of life we vow to pay forward.

*With love and gratitude beyond measure,*
*Daddy and Mama*
*xoxo*

**Alice de Almeida:** *Matilda*

*Dear Matilda,*

I am not sure if you know the history of your lineage as the official cat of the Algonquin Hotel. I will tell you my version of the story, but feel free to read up on the plentiful other versions that exist while you are lounging around on the reservation desk. In the 1930s, the Algonquin was one of the premier hotels in New York—a real hot spot. A stray marmalade cat wandered into the lobby one day, and hotel owner Frank Case adopted him and named him Rusty. Rusty had the complete run of the hotel at the time. He had a special cat door that opened into the hotel kitchen, and he would belly up to the hotel bar, where he was served milk in a champagne glass.

It is said that they decided to change Rusty's name to Hamlet in honor of the character that famous actor and frequent guest John Barrymore was playing on Broadway at the time. They felt the name was more fitting. When Rusty/Hamlet passed away, the tradition of a hotel cat continued over many years and that name stuck. Now you look at me through your curious eyes and scratch your whiskers as if to say, "But why then is my name Matilda?" That, my sweet companion, remains a mystery. All I know is that after seven Hamlets, there were three Matildas—and here you are!

Your presence in the lobby makes our day so much brighter. You bring smiles to guests and associates alike. You make us feel "at home." You may be the tenth Algonquin feline, but you are our number one! You rule the roost and all of us. You are truly our "Algon-queen."

*Have a PURRfect day!*  ^..^
> <

Dear Lucki,

We gave you your name because we believed that you were lucky to have found our house that cold morning in February. You were lucky that we had cleaned up the yard enough to see you hiding under a bush and that our efforts, along with the help of our vet, saved your life. We never thought that you really deserved your name because we were lucky to have found you!

We are lucky to have a cat that loves everyone and that everyone loves back. Thank you for being so willing to walk on a leash at the beach, down the street, or even around the pet store. We love it when you dress in costume with us at Halloween. We are sure that your willingness to happily wear the jersey or cheerleading outfit of our favorite football teams helps them to win more games! The dog trainers and owners who teach obedience classes are all very lucky to have a cat like you that is not afraid of dogs and helps them work on being calm when there are distractions.

Thank you for showing all those "dog people" that they can be cat lovers too.

You prove to the world that "wild" animals can sometimes be tamed and that rescuing a pet could be one of the best decisions a person can ever make!

Love always,
Mommy, Daddy, and your "sister," baby Dori

Grace Dennis: *Timmy*

Dear Timmy,

My cat. You're really fuzzy. Sometimes you look like a goat. But you're a great singer, you sound like a zombie and you know that's awesome. Anyway, just saying, your cat food is really stinky, no offense. I really like the fact that you're warm because when my feet are cold you heat them up. So thank you.

Love,
Grace (age 8)

*Dear #cat,*

    After moving into a new house, the roommate and I decided the place needed a little livening up. We both liked cats a lot and the shelter wasn't far, so we took a drive just to "look." Well, no one can just go "look" at kittens and cats, and of course we found you! You were already a year old, surrounded by hundreds of kittens and patiently waiting. You stuck your white arm out and latched onto my shirt, and I knew you were the one. It took a little while to figure out a name, but it is the modern age and #cat (hashtag cat) fit perfectly. Since that day there hasn't been a dull moment at the house. From you putting your paw on every piece of food I cook as if claiming it as your own, to jamming your head into every glass of water I pour while your bowl sits a few feet away. There's something special about when I lie down and you hop on my stomach and start purring. Or when you think the dog's tail is a piece of yarn and chew on it. Or when you stare into my eyes as I clean your litter box . . . Well, I don't love that. Anyways, it's been a really fun time with you so far! But just remember to be nice, keep the place clean, respect the guests, and not walk on my face while I sleep . . . because I saved the receipt and I could bring you back at any moment! :)

*Love,*
*Paul*

P.S. I was kidding about bringing you back, but still be nice, please.

*Paisley! aka Pais, Paisles, Tiger-Lilly, Todd,*

Hi, Paisles! You are definitely the best cat ever! I remember driving five hours to a middle-of-nowhere shelter in North Carolina to go get you after finding you online, and I'm pretty sure you're the reason we didn't get a ticket when we got pulled over on the way home. You were so tiny and used to climb up my PJs and then not know what to do when you got to my face . . . it was so cute. Then you got heavier and it started hurting, so I had to pick you up and hang you over my shoulder.

Thanks for putting up with my dressing you up, playing zombie kitty with you, and putting you in your cat stroller that your grandparents got you for Christmas! LOL! I feel like you were more embarrassed than I was when I pushed you around in Minnesota. (Sorry I still don't have the guts to bring your stroller to NYC.)

Even though you beat up your pug big brother occasionally, it's kind of awesome watching you chase your tail and sit on command like he does, and one day I may have to tell you that you are a cat. But if you want to be a dog, I accept you for that too. I also appreciate waking up in a pile of strings after you drag them all into bed every night. Best Cat Ever. I love you.

*xoxo,*
*Mom*

**Jackson Galaxy:** *Velouria*

*Dear Velouria,*

It was so long ago, you might not remember the day we met. I almost tripped over you—a little ball of brown fluff sitting outside of a produce box, with your little brother still inside.

I assumed you were about five months old. A commandment among shelter workers is "Thou shalt not adopt a kitten." As the advocates for homeless animals, we were always adopting the "dented cans"—the seniors, the physically challenged. But there you were and you immediately started calling to me. I knew I was doomed because your name instantly came to me when I picked you up for the first time. Your fur was so soft—the Pixies song "Velouria" seemed to have been written with you in mind.

As a teacher I treasure you; I hold you up to my audience and students as proof that it is criminal to pigeonhole the character of any individual. For close to ten of your twenty-one years, you were what we would call a "scaredy cat," "skittish," the "pariah" of any given group of cats. Always the picked on, always the last in line for meals, always relegated to the foot of the bed while others enjoyed my chest or pillow. Suddenly one day it was as if you realized that this way of life was your choice, and you could just as easily choose to be strong, confident, and assertive. Bang! The change was made.

As Black Francis wrote, though I'm not sure he had a cat companion in mind:

*We will wade in the shine of the ever*
*We will wade in the tides of the summer*
*Every summer*
*Every*
*my Velouria*

I love and appreciate you more than you could know. You have been my feline Sherpa through the years of discovering my true purpose and bringing the message of mojo to the world, a message you embody and flaunt. You have seen me at my absolute bottom and been a witness to my rebirth. There hasn't been a day that has gone by in twenty-one years that I haven't stilled my busy mind long enough to tell you how much I love you and appreciate the universe for putting you at the door of the shelter. Thank you, universe, for gifting me such a friend.

*Jackson*

Dear Sydders and Tokes (Sydney and Tokyo),

I was always taught to be careful who I met through Craigslist. But from the moment those two little balls of fur came tumbling out of that Trader Joe's paper bag onto my coffee table, my heart cracked and all fears were allayed. Who would have thought that a party monster like me could spend New Year's Eve alone on his couch, cuddling a couple of kittens. Three years later and we're still getting it done. We've had our ups and downs (mostly poo related), but we always work things out. Despite our disagreements about destroyed furniture, vet visits, and food flavor variety, you've never scratched me (deliberately) or run away (for more than eight hours.)

When we moved into our new home and I saw that giant mofo rat eating your food, I'm ashamed to say I thought you had both met your match. But the next morning, lo and behold, its corpse lay there in the middle of the living room rug, the grandest of offerings to your one true God. You will never know how much you have helped me through my life's most difficult challenges, and I promise to continue to spoil and care for you for so long as we walk this earth together. I love you both more than the stars in the sky.

*Jason*

Willy-

My lost boy . . .

You were unwanted, scared, and unhappy.

I felt unwanted, scared, unhappy, and lost.

When I first saw you, I fell instantly in love with you. I couldn't leave you there in that crate another second. I know you can't say it, but I know I saved you just as much as you saved me. Mama loves you, my little boy.

I don't give you treats every day because we have to watch your figure. But know my love for you is an even better treat! My Willers!

Love,
Mom

**Claudene Garmon:** *Charlie*

*Dear Charlie,*

   I was not looking for a cat when you came into my life. I was volunteering at the local shelter when I saw you lying on your back in the small cage with all four feet up in the air. You stuck one front paw over your head and out the door of your cage as if to say, "Hey, look at me. Won't you take me home with you?" That is exactly what I did. You would be the perfect candidate for the Pet-Provided Therapy Program. You loved both humans and animals and you were very mellow. Nothing seemed to bother you.

   Soon you became a certified therapy cat. You worked at assisted-living facilities and skilled nursing facilities. You charmed the residents with your calm, loving, friendly personality. You reminded them of their own cats and you listened attentively while they stroked you and told you stories about their own pets.

   Your favorite volunteer work as a therapy cat was with children at the local elementary school. We started a program called "Read to the Cat." Each student would read to you individually. They loved reading to you while you sat beside them. You really helped the boys and girls gain confidence in reading out loud. You never corrected them; you just listened with unconditional love. To you, they all were awesome readers. One fourth-grade boy made such an improvement in his reading skills in one year that his teacher asked him, "To what do you attribute your improved reading?" The boy's response was, "Reading to Charlie."

You have been an elegant, dedicated, committed cat in the Pet-Provided Therapy Program. You have made me very proud to be your mom. I have had cats all of my life and none has ever been as special as you. You spread so much joy, happiness, and unconditional love to everyone you meet. That is why I have given you the title "Ambassador of Love." I love you so much. I am so thankful that you are a part of my life. You are the best cat that I have ever had.

Love,
Mom xoxo

**Gina Gershon:** *Cleo*

*To my Cleohold,*

You are the only being on this planet that can boss me around the way you do and completely get away with it.

You have been my best friend, muse, traveling companion, and true love for the past seventeen years. You have gotten me through the best of times and the darkest of times. Even though you smack unsuspecting people in the face at five in the morning, demanding to be fed, they all fall in love with you. You have trained us all so annoyingly well.

I love you so much it's a bit weird.

Thank you for making my life infinitely better.

*Always,*
*your ever-loving human,*
*Gina*

**Fiona Gubelmann:** *Bijou*

*My little Bijou-bee,*

I knew when we first adopted you that it might be a little challenging. "Challenging" was definitely an understatement. More like turbulent. With your limited vision and health issues and our two punk cats, it was very hard on all of us. But your spunk, and our tenacity, somehow blossomed into something spectacular.

For two years we couldn't pick you up or pet you. It's been amazing seeing you warm up to all of us, especially grumpy Dragon. I love watching you bat at Dragon's tail as if it's your own personal cat toy. I'll never forget the first time you jumped on our bed; I smiled the whole three seconds you explored. It makes me giggle to see you bounce around the house chirping as you chase shadows. Once you hid under a bed to sleep. Now it warms my heart to see you sleeping on the sunlit rug without fear. I love that you move like an animatronic cat in *Pirates of the Caribbean*. And that for no known reason, you bound into a room when you hear whistling, especially if it's the *Back to the Future* or *Gremlins* theme song. And I love that when we pet you, you turn into an ostrich, burying your head into the ground. It's so weird and utterly adorable.

Thank you for teaching me patience. And that true unconditional love is not on my terms. You are our diamond in the rough. We treasure you, and so it's fitting that your name, Bijou, means small jewel or gem.

*I love you,*
*Fiona*

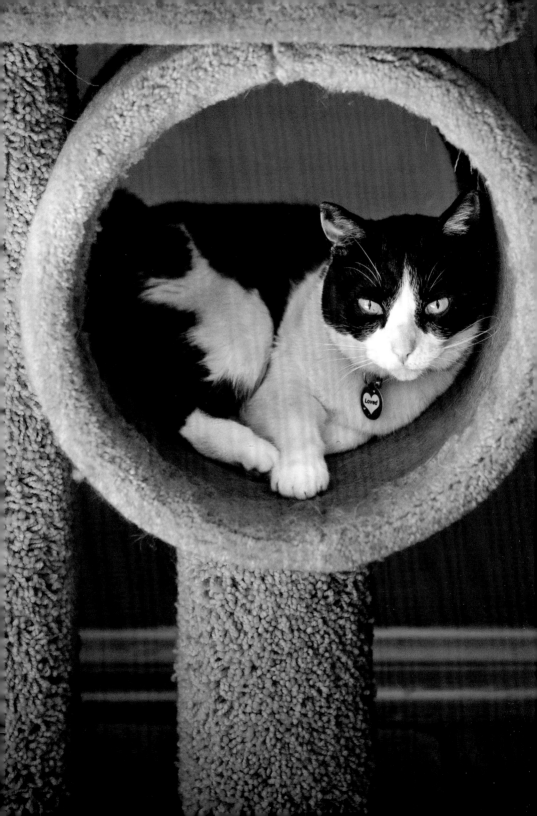

**Karen "Doc" Halligan:** *Kinky Girl*

*Dear Kinky Girl,*

The veterinary tech who picked you up as an orphaned, skinny stray, held you upside down, and said, "This is a special cat" was so right! You are truly one of a kind, and because of your tolerant personality I am able to teach children and adults to be kind to animals.

Some of my most precious memories are of us going to schools to meet children who have never been able to pet a cat, let alone listen to their heart, feel their coarse tongue, and hold such an amazing creature from God. I truly believe you have saved cats' lives by teaching others that cats do have souls and hearts and are misunderstood, persecuted, and sometimes the object of cruelty.

Taking you to a hospice, which I was afraid to visit, only inspired me to live each day as if it was my last . . . and to see how you brightened the face of everyone who met you taught me to live unselfishly and to give love as often as I could. If I had only days or months to live, I would embark on a road trip with you to touch as many people as we could so we could inspire others to adopt or rescue one of the millions of kittens/cats in the shelters that never get to see a loving home.

Many a night your soft purr has quieted my mind and helped me fall asleep. I will never be able to thank you enough for your willingness to accompany me on my journey in life, and I hope you know I love you with all my heart!

*Xoxo,*
*Mom*

**Laureen Harper:** *Gypsy*

*To Gypsy:*

Do you remember how we first met?

It wasn't love at first sight. You were a foundling—a ward of the Humane Society—recently rescued by kind strangers. You were thin and sick and injured. You yowled in your cage, railing against your confinement.

As I walked by, your little paw reached out, stopping me in my tracks. You looked at me with your baleful, encrusted eyes. Your matted fur was in terrible shape, and you were nothing like the cute tabby kitten I'd planned on bringing home. But there was such hope in your gaze I knew I couldn't leave you.

You were so thin my husband wondered if I'd brought you home to die. He was concerned that our children would be left heartbroken. But before long you even had the prime minister wrapped around your battered paw.

By the time your injuries had healed and you began to gain weight, you'd become an integral part of our family. I wish I could thank the Good Samaritans who rescued you. They might be surprised to know that the prime minister fills your breakfast bowl. And that you mingle with rock stars and presidents, philanthropists and thought leaders, shedding on everyone equally, regardless of their wealth or stature. Because of you, we always have a lint roller at the ready.

Love is a strange thing. I didn't pick you. You chose me. And while I had silly notions about what I wanted, it turns out that you, Gypsy, were exactly what I needed. After nine years, you still make me laugh and warm my feet. You rule our home with your imperial grace, and will always be the queen of our hearts.

*I love you, Gypsy Queen.*

*Dear Mow,*

    You are a cool cat in a mysterious white furry frame. You live life on your terms. You take off for untold amounts of time to hunt, scout, fight neighbor cats, and show your handsome swagger to the girls. Finally, when it suits you, you arrive home and demand a plate of particular fish, a saucer of milk, and a glass of water, which you will only drink from on top of the counter. You give me a stare, a swish, and I am granted a moment to pet you. When you won't take it anymore you swat me away in a playful gesture, never allowing your

very sharp claws to harm me. Soon the heavy purring lets me know that it's time for bed. You make muffins on my chest till the sleep lies heavy on your eyes and you settle in for an evening of dreaming of your next big adventure.

To be honest I was never a big cat person till I met you . . . I feel we have been together before in another life or perhaps just another neighborhood . . . because when you look at me with those intense pistachio-colored eyes, I know that you know that I adore you. You are a fascinating boy with a head full of intrigue and a superior plan that will be revealed in your own time. I look forward to every day that you decide to make your plan known to me, and to sharing our lives together. Thank you for gracing me with your elegant and feline fabulousness.

I love you, Señor Mow.

Sincerely,
Mariel, Mommy, friend, human who may
sometimes get what it means to be a cool cat

### To Mercury (Roman god of messages):

My oldest kitty . . . thanks for being my traveling companion all those years on the road. You visited almost all fifty states—and let me know that twenty-four-hour sunshine in Alaska was *not* what you signed up for. I'm sorry that I gave you two brothers and two sisters when you were the only child for so long. You clearly want nothing to do with them,  but it warms my heart that you still crawl over the mound of pets (hissing the whole way) to snuggle with me each night. Falling asleep to the sound of purring makes for happy dreaming.

### To Eros (Greek god of love):

You are, and will always remain, the king of the household—the cool dude who grew to twenty pounds, when at one time you fit in just the palm of my hand. You never let anything bother you, except for that pesky electric litter box that you beat the crap out of (literally). In spite of your size, speed, and obvious ability to hunt, you are sweet to every human, feline, and pooch. Though most of the time you act like a dog rather than a cat, I somehow know that when you look in the mirror, there is a large tiger staring back at you.

To Simba ("king" or "power"):

The baby of the group! You are shy and lovable, and can pull off the "Puss-in-Boots" innocent look like no other. You are a mama's boy in the best possible way—you let me know that you need me every day, an unusual trait for a cat. Whenever I return home (whether it's from a quick jaunt to the grocery store or a ten-day shoot), you greet me at the door with a spring in your step and a purr-meow mix of song that can only be described as love.

I'm thankful every day that you help me find peace in an otherwise crazy world. Thanks for keeping me "Zen," and reminding me that when life gets crappy, clean the litter box and move on.

Love,
Paige

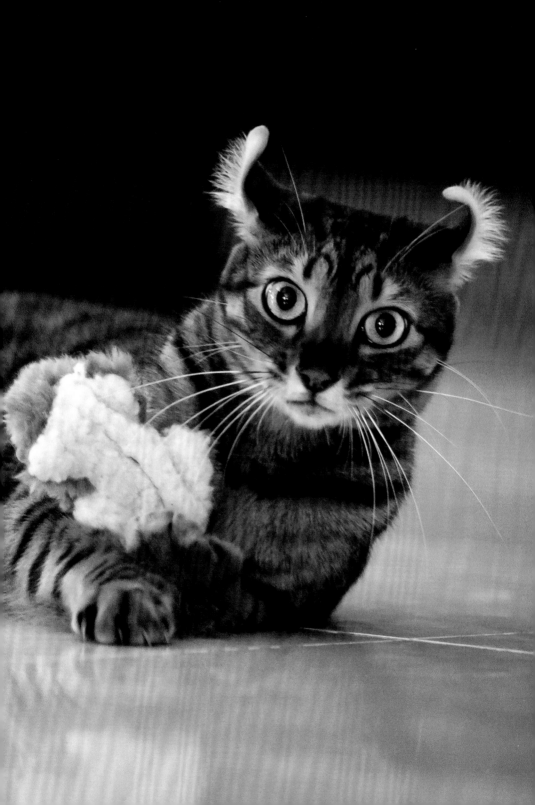

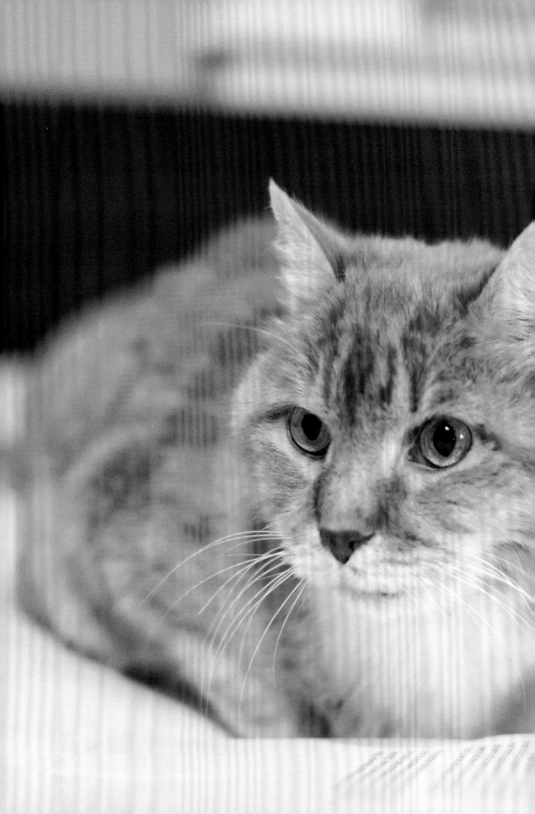

Bubba,

"I don't like cats," I told my boyfriend, "but I like yours." You seemed sweeter, gentler than the creatures I had known. I liked the way you drooled when I petted you. A little drip of gratitude as I made a swirling motion between your ears.

On mornings when I was supposed to be writing, I would lie in bed, feeling guilty and hopeless, and you would pad up on the duvet and curl up on my chest and blink yourself to sleep, and this ritual was like a balm to my lost soul. How come no one told me that cats had superpowers like this?

"I'm moving to New York," I said when that relationship was over, "and I'm taking your cat." And that guy knew better than to fight me. You might have been his pet, but you were my love.

So you flew on a plane like a real adventurer, and I have never seen such fear in your eyes as at the moment the wheels scuffed off the tarmac, like the entire world had cracked open. I scurried to push a second pill in your mouth: *Trust me,* I told you. *We'll be okay.*

The years that followed were mostly good. I renamed you: Bubba. A new name for our new life together. And on nights when my world did crack open, you stayed beside me, in a mess of blankets and wet Kleenex or on the cold tile of the bathroom floor, and though you never said it, what I heard was: *Trust me. We'll be okay.*

It's been more than a decade since I met you, and you're almost seventeen now. An old man. But you still wake me up every morning, one soft paw to the face, and I make the swirling motion between your ears, even though you no longer drool. I remind you that you are loved, and you remind me that I am needed. And we begin another day, neither of us alone.

Your friend,
Sarah

*Dear Gloria,*

Why on earth I am writing to you I don't know, because the truth is, you can't read.

I don't know if anybody else's cat can, but you certainly can't. If you could, you would have read the sign above our door that said no more legs.

That's right, with three dogs, an elderly cat, a tortoise, and five lovebirds, the last thing we needed was another set of pet legs in the house. Let alone a stray kitten who fell out of a tree into my hands during a summer storm.

And then just as we began to think you might be quite sweet, you went and broke your kitten leg and we had to fly you off the island to see the vet, causing endless weeks coping with that kitty cast. And you took full advantage of the situation, swiping the dachshund over his head with your weighty cast when you thought we were not looking.

And now as you reach adolescence your behavior has become worse: you attack our toes at night as we try to sleep, you chew off the tails of peaceful sunbathing lizards, and you proudly stand in the doorway intimidating the big dogs, who limp away, frightened to come in.

We've learned that ginger cats are normally males. A female ginger is most unusual. This might explain quite a bit.

*Take a chill pill, Gloria. It's island time.*
*India*

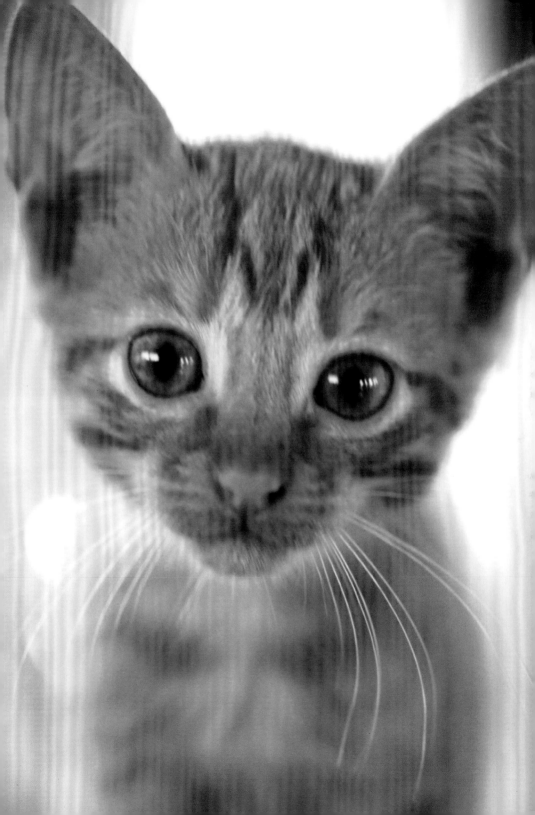

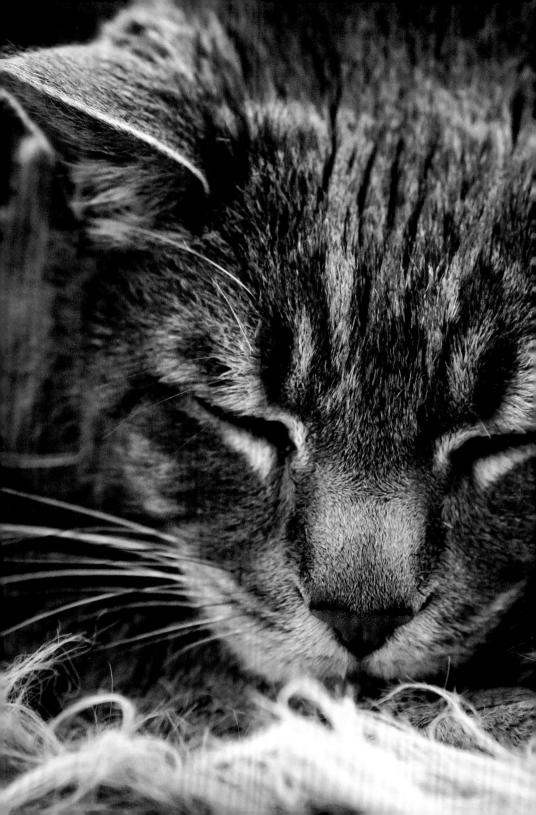

Carrie Ann Inaba: *Taz*

Dear Taz,

I love you. My one-kidneyed medical miracle . . . your love is like a warm, furry blanket on a cold winter evening. At twenty-two pounds, you are a big pillow of love. If ever there was peace, I have found mine with you, Taz-Man. When you were sick and had those surgeries for your chronic kidney condition, I remember praying to God not to take you, to allow us to have more time together, as I rushed over to the hospital right after the premiere of *Dancing with the Stars*. In Uggs and my gown, I drove straight to San Diego from Los Angeles and got ready to spend every moment I could giving you my love to show you not to give up. And you didn't. After three surgeries, each a little more risky than the previous one, you always surprised the doctors and came back stronger than ever. As if nothing was wrong. And even now—with your esophageal feeding tube through which I give you water four times a day to keep your kidney strong and healthy—you do not act sick. You do not think you are sick and when I look at you, I see only vibrant health. Because that is your choice. You are strong . . . and you are pure with your intent to live each day with love and peace in your heart.

I have been so fortunate to have been able to share my life with you. That day I found you on the street is one I will always be thankful for. You have been my protector and my friend—my guide to peace and my love pillow at night when life gets me down. You've taught me that love is all that matters. And I'm grateful.

And I'm proud to be your mama. I love you, Tazzie Boy.

Love,
Mommy

*Dear PG,*

What a joy to write this letter of memories and love to you. Every member of our family smiles when we think of you, see you, or mention your name. You are so special to us, because you were given to us to love and protect. We have never felt like your owners. We are your guardians. Your first guardian, Grandmother April, loved all the Bond girls. When she first saw you, she said, "She reminds me of Pussy Galore from the James Bond movie *Goldfinger.*" The name stuck, and after Grandmother April went to heaven, you came to live with us. Your name raised many eyebrows, so we settled on calling you PG.

Thank you for allowing us to give you wild haircuts. We've gone through so many phases. After our family began to know and love Elizabeth Taylor, you lived through a Cleopatra phase. When we brought Gracie and Delilah home after Elizabeth's memorial service, you embraced those two Maltese divas with an open heart. You recognized their loss intuitively. You showered them with motherly love. If the world could get along like our cat and dogs, we would live in a place of peace.

The incredible, sweet smell of your scented cat shampoo makes the whole house feel fresh. No one chases the electric robot vacuum like you. You remind us to do the wash when you notice that the laundry basket is too full by coming to us and meowing. The way you do a little dance to the sound of popping popcorn is hysterical.

Once upon a time I worked as a model, so I've seen a lot of photographs taken, and no cat is a finer model than you. We can always tell when you're ready for your close-up. I suppose that's part of being named for one of the most famous Bond girls of all time. We love you every day and we cherish the wonderful memories we share. You're more than a cat. You're more than a loved one. You are a gift from God and a special angel.

God bless you.

*Love,*
*Kathy*

**Alex Jeffries:** *Hova*

Dear Hova,

You once lived beneath the exposed stairs of a two-story apartment building, adjacent to an Armenian bakery and an incredible taco stand. Glory and I walked by one evening and said hello to you. You minded your own business. After all, you were nearly six weeks old. Practically a grown-up!

A week later, we walked by again. There was a couple trying to lure you over, but to no avail. You slinked by them.

So, naturally, on the third week when we walked by and saw you, we nabbed you and took you home with us. You didn't hiss, you didn't snarl. You weren't so tough after all.

Hov, you're a cat who knows what she wants. You need your pillow fort made in the morning before we leave for work. You need the window opened to look out and watch the many speeding Mercedes on our street. You need the door ajar to feel the cool, cool breezes of so many Los Angeles evenings. You're assertive and confident.

Sometimes you need to be petted, sometimes you need a lap to sit on, and sometimes you need to be picked up—but I've learned to do these things when you let us know you need them, and not a moment before. (I have the scratches to prove it.)

But with all that, it's been such a comfort having you in our home. To know that each time I come home tired and beat from a day of work, you're there in the kitchen for a hug. Or on a quiet Sunday morning you'll hop up on the table and read the *Times* with me (or so I like to think).

You're a slinking, stealthy, silly fixture in our lives, and I couldn't be happier.

Love,
The One Who Puts Out the Crunchies
in the Morning

Dear Gia,

I'm so grateful I found you as a little kitten while jogging at the lake. You showed up around the same time as my husband. Somehow my relationship with the husband ran its lovely course of love, but our love will never end.

When you somehow got injured and broke your leg . . . we persevered, and thank God surgery was the cure.

You healed from it all, even at sixteen years old. Since that injury you have taught me to persevere no matter what the circumstance and that time heals all wounds.

You continue to heal me every day with all the unconditional love, companionship, and forgiveness you give me. Thank you for all of the lessons you teach me. You are one love that will truly be "'til death do us part"!

I love you dearly, Gia.

Love,
Rachel

**Dr. Betsy Kennon:** *Scooter*

Dear Scooter,

I've had dogs and cats all my life. And I've been a veterinarian for over thirty years. So I have had many close relationships with animals. But none of them even begins to compare to my relationship with you.

I'll never forget the day you came into my life. One of my clients rushed in with you in his arms. His dog had just carried you into his yard, and you were obviously badly hurt, and because he assumed his dog was responsible for your injuries, he was very upset.

My first look at you was pretty bleak. You were in shock, just lying there on my exam table. And you had no feeling or movement in either of your rear legs, so I knew your spinal cord was shot. But there weren't any marks anywhere on your body. I searched. So I was able to reassure the dog's owner that his dog had not caused your injuries. Why that dog carried you home, I still wonder to this day.

What happened next, I cannot explain. We took an X-ray and saw that one of your vertebrae had been crushed, so there was no real hope you would ever regain the use of your rear legs. You were only about six months old; I could tell by your teeth. And you had no collar or microchip, no way for us to contact whoever might have owned you. The logical thing to do was to put you to sleep. But as I was thinking this—and feel free to get a shrink on speed dial when I say this—I actually heard a voice in my head say, "Do not put this cat to sleep." So I didn't.

Over the next few days, you managed to charm the pants off everyone at the clinic. One of the techs made you a Tupperware box with a wheel on the bottom, and we would put your limp rear end in it and delight in the way you scooted yourself all over the place—hence your name.

So it dawned on me—you liked people and you were not one bit distressed by your disability. And that, my dear cat, was the beginning of our partnership. You see, you are not just a pet to me.

You and I are working partners, a team, like policemen and their police dogs. For more than five years now we have visited our local hospital and three nursing homes once or twice a week.

I remember when you performed your very first miracle. We came to the room of a new patient. The therapist and the nurse who were with us took me aside before we went in and told me this woman would be "flat." When I asked what that meant, they said she had just had a stroke and would not speak or open her eyes. But they thought she might like cats, as her family had put some photos of cats on her bulletin board.

I lifted you, cart and all, up onto her bed and gently placed her hand on your head so she could feel you. You, my magic cat, somehow knew to snuggle right up against her. And don't you know, she opened up her eyes, smiled a great big smile, and started talking a blue streak to you while she petted and petted your head. I thought, Wow, that's pretty cool! But I didn't realize just how cool until I turned to look at the therapist and the nurse. They were both in tears.

Since then, there have been more miracles than I can count. Your disposition is so sweet and calm, your fur is so soft, and you are such a handsome cat that you are just perfect for the job we do together. Having a permanent disability that you can show the world is not a handicap to you—it's just icing on the cake.

There were so many coincidences that brought us together and started us on this path, that I have to believe the big guy upstairs had a hand in this.

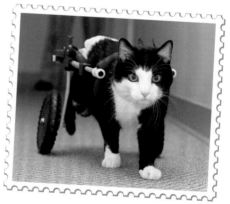

Whatever the case, I am eternally grateful to Him, and to you, for all you bring to my life and to the lives of others.

I love you. I just hope you know how much.

Love,
Mom

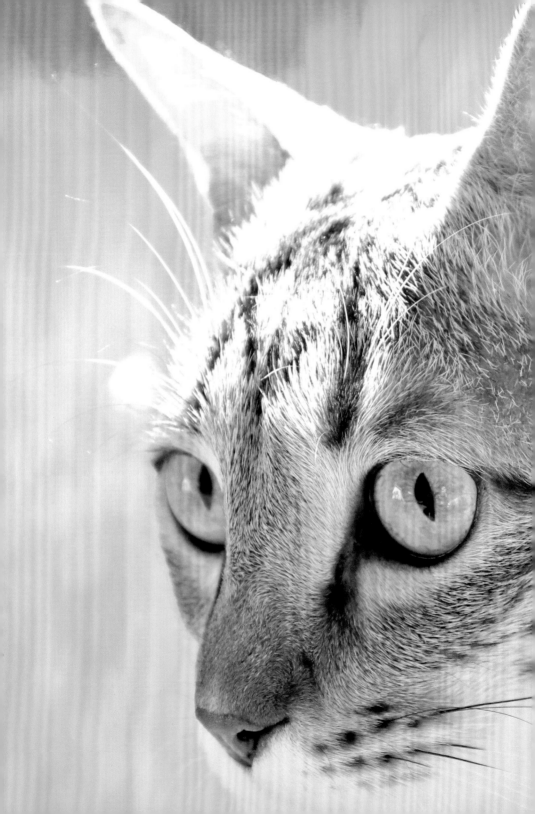

Dear Koshka,

I first met you in Afghanistan, where I was stationed as a staff sergeant in the US Army. I thought you were just a cute kitten that would come and go from the base. Later, when it became evident that you were being hurt and abused, I committed to taking care of you. I knew I was breaking the rules, keeping an animal on base, but how could I risk you leaving and going back out to your tormentors? I snuck you into my office and fed you canned salmon smuggled from the cafeteria.

I didn't know that months later, you would rescue me. A suicide bomber attacked one of our patrols—one that I was initially supposed to be on. Several of my platoon members died.

I had lost all hope, given up on my life, and was ready to end my pain the only way I knew how. It was you who showed me a different way. You, my friend who had suffered abuse, abandonment, and despair, were there to remind me that no matter how horrible I felt, there were still people who counted on me and who needed me.

Throughout all of the darkness and pain, one little cat was the most  beautiful and important thing in my life, if even just for a moment.  It was then that my commitment to you became my drive, my new purpose, and I knew one way or another I would keep you safe  as you kept me safe.

It wasn't easy, but we got it done, thanks to a team of kindhearted people: the interpreter who bravely risked his life secretly transporting you to Kabul; the animal rescue group that helped facilitate your transport out of Afghanistan; and my loving mother, who raised nearly $3,000 for your airfare by selling quilt patterns featuring cats.

Through it all, we both survived. Koshka, my friend, I may have given you food and shelter, but you gave me my life and my purpose.

Jesse

Dear Phillip,

You don't know this, because you're a cat, but there is a kind of human—specifically, a kind of human *lady*—known in our world as a "Cat Lady." This may shock you from the tips of your whiskers down to the end of your tail, but a Cat Lady is someone who gets made fun of. A lot. I should know.

When I walked into the shelter six years ago, you placed your tiny paws on either side of my face and held it. You held my gaze. And when I set you down on the counter to fill out the adoption paperwork, you started sneezing, coughing, and convulsing at the same time. Green stuff flew everywhere, but still I paid no heed to the shelter worker's warning: "I'd choose a different one if I were you." It was too late. You were My Cat, and I was your Cat Lady.

You jump into my arms and throw your arms around my neck to hug me in the morning, even though no one believes me. You sleep in the crook inside the numeral four shape of my legs every night. When I have a brilliant idea in the middle of the night, you don't care. When my hair looks amazing, you don't care. When I lose two pounds, as far as you're concerned, there's just less of my belly chub to knead.

People think I'm weird because I love my cat so much. I feel sorry for them, Phillip, because they're missing out on your hairballs, your rage when the state of your litter box isn't up to your high standards, the way you can steal lunch meat out of a sandwich the way a magician yanks a tablecloth off the table without disturbing the place settings. They're missing out on the things that make you one in a kazillion, and it's those things, those stupid, pain-in-the-butt things, that make you my best friend.

I am proud to be your Cat Lady.

Love,
Me

**Nina Laden:** *Cali*

*Oh, my dear Cali,*

Cancer brought you to us, and now cancer is taking you away.

I will never forget the day we met. You were on the corner of our street and you ran out to greet us, my husband and me. You were telling us a story, but I didn't speak cat. After you followed us for a mile, I decided to ask the guy in the house that you greeted us in front of what your story was.

He told us that you were three years old and that your first "person," his sister-in-law, had died from cancer. You needed a home because you didn't get along with his cat, so he had put you outside. That was not good enough for a feisty feline such as yourself. You wanted your own house and family and you chose us.

For so many years we were a family unit: five humans and a feline. You sat on a high stool while we cooked and ate, and you always participated. Our friends fell in love with you, even the ones who didn't like cats. You talked to them; you paid attention to them; you took their laps for a test drive, and they always left saying that you were "the only cat we liked."

I wish I could have read your mind or your actions when you started acting so strangely four months back. There was a tumor growing in your leg. By the time we discovered it, it was too late. Our hearts were broken as the vet told us that at your age it was not good to go down that long road of oncologists and test after test, but we understood. All we could do is love you and treat the pain.

We are doing just that and it is helping you a little, but we know the end is coming soon. The pain from that knowledge is killing us. Little Bird Cali—we will have to give you wings when we know that you hurt too much because that is the best we can do to make your journey easier. Our journeys are not over yet, but I hope that we can all find each other someday somewhere where there is always good food and no one gets sick.

*Your human,*
*Nina*

Dear Jackson (aka Jaxie Cat, Jaxie, Jax, Jooxie, Jaxie Bear, and BooBooFace),

It's hard to believe we've been together for seven years now. Yet, it's even harder to fathom that you weren't in my life for the first seven years of yours.

Rescuing you and making you a huge part of my family has turned out to be one of the greatest pleasures of my life. I hope you feel the same. We've all come such a long way since we brought you home. I remember how you spent months trying to find clever places to hide—under beds, in closets, and behind sink pipes (thanks for giving me fifty mini heart attacks, BTW!).

Once we earned your trust, you showed us your true colors and became the most loyal friend anyone could have.

You're gorgeous—that's obvious. But there's so much more to love about you than your fluffy Maine Coon coat and deep green eyes. I love the way you curl up in my arms every night and purr so loudly that it stops me from falling asleep. I love all the kitty kisses on demand, the complete conversations we have with each other, your loud snoring (cutest thing *ever!*), and our midday naps. I also love the way you wait in line for the bathroom, how you climb on Daddy and me to "make biscuits" on us on Sunday mornings, how you open the cabinets in search of food, and the fact that you're glued to my side when I'm not feeling well. I even like when you poke me in the face to wake me up whenever you feel like playing.

I find it hard to believe that I can be so deeply attached to a small beast who's as unproductive and lazy as you are, but there's no doubt about it—you are my furriest, best little friend in the world and I couldn't possibly love you more.

Love and xoxoxoxoxos,
Mommy

Dear Baby AI,
    You have many nicknames,
    Let's start with a few:
    To B.A., Bear, and Furby
    You answer on cue.

    You are furry and purry,
    As loud as a train.
    You love snuggles and cuddles,
    You like to stare at the rain.

    We met when you were four
      months,
    As scared as a lamb.
    They called me and said,
    "We found one for you, ma'am."

    You hid in the litter box
    When I came to meet.
    I lifted the cover,
    You shook like a leaf.

    "I will name you Aloitius,"
    I pronounced with a cry
    Because you were delicious
    And that is no lie.

    You started to sleep
    Right next to my head,
    You started to yell
    For your cuddles in bed.

You started to come
Right out of your shell
And give nightly face baths
That were almost from Hell.

You talk to me endlessly
In purrs and meows,
But I understand every word
As if they were bonjours and ciaos.

I was once told that
Cats are angels in disguise,
That they come when they're
    needed
And go when they recognize
They have loved and brought
What they needed to bring
To the lives of the humans
To whom they cling.

Baby AI, what you've brought me
Is so hard to name
But for sure it is love,
Pure love without pain.

I am so grateful
That you've allowed me
To take care of you
For these seventeen years,
While I grew up too.

I love you,
Mommy

*Hey!*

Where would I be without you?

Before I met you, I thought I loved someone who did nothing but tell me I wasn't good enough. I lost all my confidence. I was in a pretty bad place. One day, I thought getting a cat might make me happier. That's when I found you, and even though you were four hundred miles away, I was determined to have you.

I'm sorry I was too indecisive to name you for months. So instead of responding to your name, you respond to "hey." I'm sorry the name I eventually chose was Pudge. I hope you don't hate me for it.

You're the first cat I've ever owned, and because of you I have so many amazing new friends. You've been my muse to become better at photography and design. You force me to step outside of my comfort zone and become less introverted.

My life was nothing but bad luck before I found you; the day I got you, it all went away. You're my lucky cat.

*I'll love you forever,*
*Kady*

**Brook Lopez:** *Poupin*

Marquis Poupin,

As I write this, we have been enduring one of the coldest winters in recent memory. Being locked away in my chamber, situated directly adjacent to the window, I have seen firsthand the results of the season's icy grasp. Yet this is not why I have taken up pen and parchment to write this letter. No, I write this letter in the form of a bill, as it seems to be impossible for you to see just how taxing it is belonging to the household and manor of the mighty Poupin.

- In reference to the ongoing frost, must you leave your aforementioned window open at all hours just so you have a sill at which to rest? I am not aware if you know how windows function and operate, but they are purposely designed transparently so that one can take in the surrounding vistas on their other side.
- I have never seen a marquis quite as pampered and outright spoiled as you, sir. Whether they be articles crafted from the finest threads of silk in the Orient, or playthings meant to enthrall one with a near nonexistent attention span, the general populace seems enamored of you and showers its feelings upon you with gifts and tribute.
- This, in turn, has brought me to the most pressing, most worrisome topic: your particularly heroic intake of rations from your number of Treat Jars. It seems that with you it is always time to partake in a "light" snack, whether it be while daylight pours across the manor grounds or as the shadows in the depths of night blanket us, when you break my slumber with your piercing voice, seemingly without a care.

I could continue on and on, but I have a show to get to and I am afraid that I am now running low on ink.

Your brother in Prince Edward Zephyr,
B. R. Lopez, Esq.

*Dear Pye,*

Since the day I saw your photo on the Humane Society website I have been smitten with your lovely countenance and charming personality. There are, however, a few issues that I would like to address here, in hopes of coming to a reasonable agreement between your wants and my needs.

1. I *need sleep,* preferably seven or eight hours' worth. When you decide that breakfast must be served at 5 a.m. (knowing full well that I turn out the lights at midnight), you can expect resistance on my part. Yowling and placing your furry, odiferous butt on my face will not get your breakfast served any faster.

2. Like socks in a dryer, my earrings seem to consistently lose their mates. I now have at least a dozen single earrings that have mysteriously been divorced from their partners. I set two earrings on the dresser every night but often find only one in the morning. Since I have *two* ears, this presents something of a problem for me.

3. Why must you make such a huge deal out of pooping in your litter box? After every event, you run up and down the stairs, through the house, caterwauling and attempting to get my attention. This, my little friend, is nothing to get excited about. You don't see *me* running around, yelling, "Woo hoo!" every morning, do you?

Finally, Pye, you make my life worth living and can have anything your little heart desires. You are the reason I trudge off to work each day (to get money to buy your expensive food, treats, toys, and litter) and the reason I come home at night (to your happy, meowing little face).

Now, can I just have the silver earring back? You know. The one with the little blue crystals?

*Signed:*
*Miss "I Have Opposable Thumbs and You Don't"*

**Wendi McLendon-Covey:** *Carmen*

Dear Carmen,

When an animal chooses me to be their human, I feel it deep down in my solar plexus and I can't just walk away. You and our other three family kitties are rescues, but believe me— you all chose us and demanded to be taken home and spoiled rotten. I guess you could tell we'd be easy to dominate.

Carmen, you came to us in an unusual way. You used to live with the family next door but gradually moved in with us and became our household supervisor. When you first moved into the neighborhood, you wouldn't even let us pet you. But over a period of several years you went from running away from us to following us on our nightly walks; from letting us tentatively pet you to letting us give you a bath; from sleeping in our garage to sleeping on my stomach; from living with another family to being so completely part of ours that I can't imagine life without you.

Thank you, all of my furry angels, for teaching me that cat scratches are more chic than expensive jewelry; that I'm never fully dressed without several layers of cat hair on my sweater; that nice furniture is overrated; that finding petrified hairballs behind the furniture is like being on an everlasting Easter egg hunt. But Carmen, you in particular are my "spirit animal," and I'm so grateful you decided to move in.

Love always,
Mama

Dear Snowball,

    You are an amazing high fiver and friend. I love you so very much. It is very funny when you attack my dad's foot when he walks around the house, and when you wait around the door for me to come home, and when I leave the house and I can hear you meowing when I'm outside the door and in the garage. Why do you like to play in my bathtub? You are an amazing friend.

    Georgia (age 8)

**Melissa Lemer Mogel:** *Pusswah*

*Dear Pusswah,*

I've always been a dog person. I didn't know the first thing about cats, let alone a miniature rug hugger like yourself.

Your size makes things a bit unusual . . . your one-inch legs, so cute and short. It still amazes me that you can jump so very high. I love your little face and tiny teeth, that gorgeous tabby coat and your huge green eyes. Despite your miniature frame, your personality is larger than life. You obviously have no idea you stand only three inches off the ground. You are drop-dead gorgeous, a supermodel.

Although I hate it when I think you are lost (which is quite often) and I rip the house apart to find you sleeping on a towel in the bathroom . . . you have taught me to trust, love, and open my heart. You have made our family complete and we are all in awe of you every single day.

I love how adventurous you are. I love how you always act like a playful kitty. I love when you sleep next to me. And mostly, I love the special relationship you have with your brother, Allen Gregory. The way you flirt with Allen and the rest of us, you are certainly in full control. Allen is in love with you. He is glued to your every move. You have him wrapped around your tiny little paw!

Pusswah, it's been six years of pure joy and laughter! I look forward to many, many more memories together. You are my little mama.

Our home would be incomplete without you. Thank you for loving us so very much.

*We love you . . .*
*Mommy and Daddy*
*and Allen Gregory*

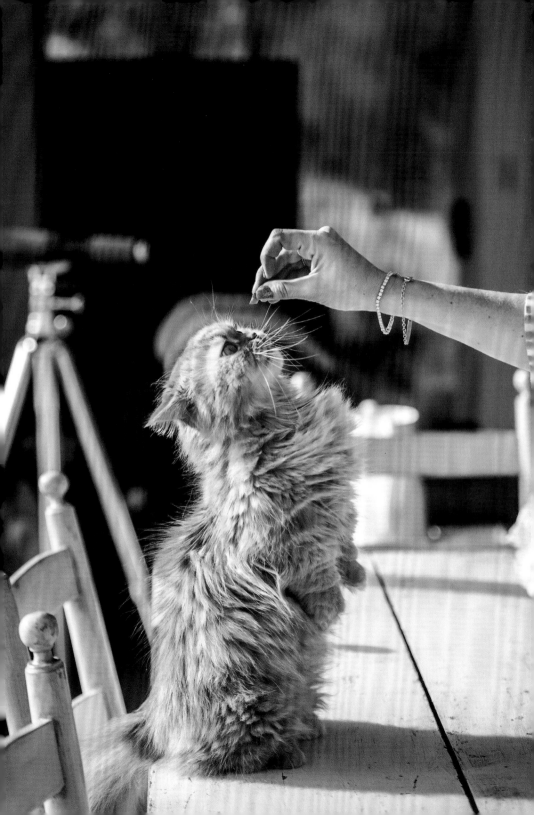

**Lisa, Clark, Ava, and Grant Morin:** *Obi*

Dear Tiki Cat (Obi),

I love you. When you came home to our family I was very happy. It seems like it was just yesterday when we got you. I remember when you and I were just sitting on the couch, both lying down, and I looked at you and then you looked at me back and we had a special moment and that was a day I will never forget.

Love, your best friend,
Ava (age 10)

Dear Obi,

I love it when we wrestle and when we each have a chance of victory. No matter how angry I am at you or you at me, we are always there for each other. No matter how many scars you give me, I will always love you. You are funny, cute, and sometimes smart and that makes you one of the most amazing cats in the world.

I will always be here for you.

Clark (age 14)

Dear Obi,

I love it when you act silly and you run around the house like you're on a racetrack . . . but what I love most is when you play with me. Sometimes I get scared and run away from you and you chase me . . . that is the most fun of all.

Love,
Grant (age 6)

Dear Obi, Obadiah, Obi-Wan Kenobi, aka "the Bird,"

When we added you to our family, your tail was broken but your spirit wasn't. The woman who gave you to us said nobody wanted you, but the minute we saw you we knew we did. You are our fearless kitty, the guardian of our house, the one who controls everything including the dog. Your uniqueness is so obvious.

When you first came home we thought we might have to send you back because of your incredibly loud purr. We even called the woman and asked her if something was wrong with you. Your purr sounds like a chortling pigeon. It's the most amazing thing about you besides the fact that you can stare down and slap down any dog that gets in your way. As unique as you are . . . . you are also typical. You have your moods, as all cats do. Everyone knows when your eyes turn from yellow to black, trouble is lurking and it's best to leave you alone. We have scars to prove it. But you are mostly a love bug.

Thank you for cuddling with me when no one else will. And at 2 a.m., when my thoughts won't let me sleep, I know I can count on you to be there.

Thank you for your unconditional love and for letting the kids treat you like a rag doll and put you in countless yoga poses.

You will always be our Tiki cat.

Love,
Lisa

*Dear Baby Cat,*

Writing this letter with you nestled right beside me, I can't help but think about how I knew from the moment you came into our lives that you were the perfect addition to our family. From the very first meeting, you were so precious, we chose to name you Baby Cat. As we cradled you tightly in our arms, the name Baby Cat came naturally to us from just how little and warm you were.

Baby Cat, you bring an incredible positive light into our lives and fill our family with laughter, love, and joy. Whether it's playing with your food, chasing the dog, or trying to catch your own tail, you never fail to keep us laughing and entertained.

You are so lovable, friendly, and loyal to us, and even more so to your canine companion, Rosie. The friendship you have with Rosie and the other cats is truly remarkable. From playing to napping with Rosie, you never fail to show your unlimited love and affection.

As a surgeon, I have always been fascinated by your and the other cats' ability to see and hunt at night. I also marvel at how, no matter how sweet you are around the house, your hunting instincts never leave you. You are always ready to crouch, pounce, and grab anything that looks like a meal you would have to capture if you lived outside. Many humans I know could take a lesson in how to balance their killer instinct with their sweeter side.

You are more than a great listener and an important part of our family, you are a lesson in how animals can express unconditional love, an expectation you rightly hold for us to return both to you and one another. You will always be our Baby Cat.

*Love,*
*Mehmet*

Dear Swayze,

I'll never forget the first time I held you. I picked you up, your purr motor already revving like a jet plane, and tucked you into my coat, against my heart, where you promptly fell asleep. I, just as quickly, fell desperately, incurably, in love.

But like all great love stories, things were complicated.

"Something's not right with that cat," someone said.

And it was true.

You were born different, Sway Sway. You were born with cerebellar hypoplasia—part of your brain's growth was stunted, the part responsible for motor skills and coordination. And, heartbreakingly, so many who are born like you aren't given a chance, put "to sleep" before the world realizes how amazing and special your uniqueness makes you.

How tragic it would have been if I didn't have the gift of loving you.

But we both got lucky, Little One, and now I have the blessing of watching you grow from the little white fluffball with big blue eyes who I first adored into the brown-streaked, handsome boy who makes my world spin 'round.

You may never understand just how fortunate I feel that I get to wake up every morning with your drool on my arm, your body wrapped as the tiniest spoon against mine. Or how happy it makes me to watch you trace infinity signs through my legs as you eagerly wait for your breakfast . . . or the way you Superman stretch and curl over my shoulder when we greet each other. Every day with you is a gift that I treasure and will forever be grateful for.

You make the world a better place and me a better person.

I love you beyond measure, Swayze.

Always,
Sasha

*Dear Icon,*

We have had many animals as part of our family over the years, everything from horses to dogs. We love and have loved them all. But there was one animal we never had a chance to make part of our clan that always intrigued us: the Maine Coon cat. In my search for a Maine Coon for my wife Billie's birthday, chance and fate brought me to a very caring breeder, and I was able to meet you in person for the first time.

As a kitten you were larger than some cats are when they are full grown! You sauntered over to me and there was an instant connection between us as you curled your body around my leg and rubbed your head on my hand. Already at this young age you moved with a grace and majesty I had never seen before. Icon, you are in a class of your own.

I love when you express yourself by actually chirping, and I even love when you wake me up at 7 a.m. with your gentle taps on my nose because you like to have me keep you company while you eat your breakfast. (There is always food out for you, you know.) This is after I explain to you I had a gig the night before and have just gotten to sleep! I really don't mind, though; your touch is always gentle and loving.

I have always been a dog person, but you won me over! Your beautiful coat, your instincts that seem to let you read our minds, the way you MUST sleep so that you're in constant touch with Billie and me. There's no denying that you're there . . . you're so BIG! In fact, when I brought you home, Billie was disappointed because she wanted a tiny kitten and she thought you were full grown! But much to her astonishment, your actions proved you were a kitten.

You came with the name "Icon" and it's the name you still have now because you live up to every definition of the word! You are truly one of a kind and have a special place in the Perry clan's heart of hearts . . . I love you and always will.

*All my best,*
*Joe*

P.S. I don't even mind the gigantic hairballs squishing between my toes at the most inconvenient times, and that's saying a lot!

**Lisa Ray:** *Coco*

*Dear Coco,*

I used to think that you were handpicked to be mine, but now I'm sure you are the one who picked me. A fortieth-birthday present from your daddy, it soon became clear you were a fluffy, pie-faced symbol for a new life. Looking beyond the fur, into your saucer-shaped eyes, tutored me on what it's like to live with an incurable disease: "Just. *Live!*" is one of our many wordless exchanges.

While you are my greatest ally in "freeing myself from approval-seeking," our relationship is even deeper than patient-therapist—the cuddles, the promise of a wet-eyed greeting at the end of tiring travel. You keep me silly and you scatter the papers on my desk to remind me not to take it all too seriously. I manage a grin when I find a layer of your hair on my little black dress when unpacking in a strange city and imagine your gravelly, Lauren Bacall–like voice (at least that's what I hear) chortling with a "Gotcha, kid!"

And we share secrets. Remember when I brought you to that photo shoot and almost lost you?

You're not just fluff, Coco-rico. Complex, discerning, powerful . . . you remind me to look beyond the fluff too.

You'll always be my furry baby, Coco-rico. Coco-GIRL.

*Love,*
*Lisa*

*Toast,*

I talked it over with the Good Samaritan who had found you and brought you in. She requested that we humanely euthanize you. It was a reasonable request. I took you to the treatment room to put an IV catheter in you that would deliver the drug that would allow you to peacefully pass away. I petted you as the nurse placed the catheter. Wait! The muscles in your back legs were atrophied. They had wasted away. That doesn't happen overnight. You'd been this way for . . . well . . . probably a month. You survived outside, a stray, for a month with paralyzed back legs! You were not a cat I could euthanize. You were a cat who wanted to live!!!

I took some X-rays of your pelvis and abdomen and saw that your hip bones had been completely crushed. Three of your backbones were luxated (out of place), but your spine was not broken. On the X-ray I could see digested bone meal in your colon. By some miracle, you had hunted on two legs. Though severely emaciated, you were able to eat just enough to stay alive. I treated your fleas and ear mites and put you in one of the hospital cages with some cat food. Man, did you chow down! I said good-night to you, my gimpy new friend, and headed home.

After a series of incredibly intense surgeries, a lot of close calls, and many visits to specialists, I finally took you home with me to foster. Your wounds healed. Your hair grew in. You gained nearly three pounds! I knew all of that would happen. But what I never expected and would have guaranteed would never occur is what happened next.

Within a week, you were moving both back legs! You were still dragging them and knuckled over, but they were moving!! Both of them. By week three, you were actually walking on your paw pads. Like a normal cat. You could step over an obstacle, go up and down the stairs, and even jump onto the counters and windowsills.

How on earth you are able to walk will remain a mystery to every veterinary professional involved in your care.

Like most vets, I am a sucker, and since you taught me so much about not giving up, I'm really glad you ended up finding a pretty good home . . . mine.

Sometimes, when I am watching you, I think back to that horrific X-ray I put up and the general consensus of every reasonable person who said, "This cat is toast." I'm glad I wasn't reasonable on that day. But that is why I named you . . . Toast.

*Love,*
*Monica*

**Michelle Salas:** *Valentino*

*Dear Tino,*

It's been a while since we met, and I have to say that every day feels like the first. You may not remember, or maybe I forgot to tell you the story, but I was waiting for you for a very long time. You were the last little baby available and I had to take a long drive to go get you. They called and told me, "There is someone else who wants to take him" and I remember I yelled into the phone, "That cat is mine! I'll be there in five MINUTES!!!"

The first moment I saw you, I really didn't have to think much. I knew it was going to be a big responsibility to have a son, especially because Mommy travels a lot for work. But I really didn't care . . . actually, Valentino, you seemed like a world traveler already, so I took you home with me.

It has been an amazing journey. I feel like I know you quite well now. I know when you're mad. I know that you play dumb when I yell "NOOOO!!!" I know that you don't like your scratcher and you prefer to scratch my luggage. I know that you hate when I upload a million photos of you on Instagram 'cause you are so cool that you should have your own account. And, especially, I know that after your "lion cut" I'm not your favorite person. But I also know that behind that super-cute grumpy face, you love me back in the same way I love you. You are the most beautiful soul I have ever met, my dear Tino.

What else can I say, my lovely Great Catsby . . .

Thank you for being such a great life companion.

*I love you, handsome!*
*Mommy*

Dear Sugar,

Straight from the North Pole and at the perfect time . . .

Sugar, you came into our family at a time when we were in great grief. You gave us something to love and snuggle with . . . we needed you. For so long, I constantly worried that something was wrong with you because you were absolutely perfect. Too good and too sweet to be true. Since then, I have realized that you just *are* perfect.

I love to watch you stand on your two hind legs and study the birds and squirrels from the back window. It's like you're glued to an action movie that you can't take your eyes off. Truth is, we probably keep those bird feeders filled up more for you than the actual critters that partake in them.

Thank you for talking to us through your giant purrs and for lying patiently and lovingly in my baby's lap for as long as she wants you to. Thank you for cuddling up to our feet at night and thank you for nibbling on my toes under the blanket. You are our little blessing. Please live a very long life with us. We will love you, feed you kitty malt from our fingers, and let you roll around in a blanket of catnip whenever the urge hits. Thank you for being everything your name implies—Pure Sugar!!

Love,
Mommy

*Burma,*

Life after the Iraq War was crushing. My old house in West Virginia felt abandoned and lonely. Sleepless nights, depression, and anger set my feet on an unfamiliar and haunted path. I used to ask why life had taken me away from the places I knew and so many loved ones I trusted, and had brought me to such a seemingly desolate existence, living with my faithful dog, Puppi, in a cold, damp Jeep in the mountains of southern Oregon.

But then one spring day, that somber path brought you into our lives. A tiny brown cat with white paws and a white mask, you were a willing part of our pack from the start, breathing new life into our lives.

God sent us a mountain lion and a dog packed into a common kitten back in April, and I can't fathom experiencing the sights we've seen or the places we've been had you not been there with us since. My harsh lifestyle provides a heavenly life for your wild spirit, and I gladly live without a roof over my head to share this experience with you. I know if someday I have an indoor home, you'll be happily close by our sides there too. You'll adapt. You'll make friends with other cats and dogs. Your real home is with us, adventure cat. But you'll always be the cat who shared some of my most beautiful and trying times every step of the way.

You're a cat I've kept from owls and osprey and hawks and eagles. You're a cat I've carried up snowcapped mountains in my arms, a cat I've slept beside in the warmth, high up on the ledges of granite walls. We've crossed steep passes from valley to valley together, and even tumbled down a ravine amid an avalanche of crushing rocks in each other's grasp. We've explored turquoise waters tucked deep in the mountains, and run along the edges of the roaring Pacific in playful stride. Our memories are already endless. Our bond is beyond words. I never want to know life without you. You are a cat for the ages. Our spirit is truly unstoppable as long as you are with us.

I love you so much, Burma!

*Smile,*
*Stephen*

Dearest Nala,

My beautiful black panther . . .

You have been by my side for the last seventeen years . . . protecting me, loving me, entertaining me.

I dreamt of having a cat since I was a little girl and my dream came true. When I first met you, you were called Black Bean. You were so tiny and shy, only eight weeks old! The woman who rescued you said you were a female. You and your brother Yogi came home with me that day and I was the happiest girl in the world.

I named you after a female character in *The Lion King* but found out at the vet a couple months later you were a male! Sorry, but the name stuck and since then you have been mistaken for a female your whole life, ha!

Nala, you completely came out of your shell and became a majestic, powerful being. You really showed your brother up with your hunting skills, yet you are always so gentle and loving with everyone you meet.

You amazing green-eyed kitty, I really cannot think of the words to describe my love and appreciation for you in my life. Every day I love waking up to you and talking with you. Yes, you talk back to me a lot and tell me whatever you need. You do a good job of tolerating the dogs, Slim more than Oscar. I didn't know the depth of love I could feel for an animal until I had you and Yogi. You both came into my life and showed me unconditional love in the purest form. Thank you for always being so loving and affectionate, sitting on my lap and snuggling with me in bed. You have made my life more complete, I love you so much!

Love,
Your Mama

**Art Smith:** *Negrita*

*Dear Negrita,*

My love for you comes from a love for all things living. With my St. Francis of Assisi upbringing and being a little Florence Nightingale, I found myself rescuing poor creatures from the cold.

You came to us some years ago . . . our little black-and-white kitty. You're really more attitude than cat. You wait patiently to hear us call to feed you, and you throw attitude when the pups invade the bed.

You're one of my many furry children . . . you welcome us home and cuddle us as we watch TV. What I love most is that you bring animation to a world that is always in need of a meow, a purr, and a hiss at your puppy brothers.

We love you!

*XO*
*Art*

*Oh Tinkerbell Stinkerbell Smithey,*

My furry shadow, my feline satellite. How blessed am I to have as dear a companion as you. Is it foolish to believe one's spirit could be so deeply entwined with that of a household cat? When I was five, you first comforted me as I lay weeping on the living room carpet. Your nurturing spirit has since remained an inexhaustible refuge of solace in many of my darkest hours, your soft fur a scratching post to dull my sharpest pains. You've enriched my heart's capacity for love.

How appropriate is your name, Tinkerbell, with your stubbornness, impatience, and jealous demand for attention. You really are a princess: a feline testament to purest innocence, playful whimsy, and feminine charm, and an infinite delight to my soul . . . It saddens me to think of a day when you'll no longer be over my shoulder watching while I paint, or waking me up in the early hours of the morning to be fed, or even frantically shoving me awake to tell me I lit the kitchen on fire. I love making you happy, Tink, because it makes me happy. I thank God for all the years you've been a source of light in my life, and pray that song of joy never cease for years to come. But I can say with absolute certainty that even after you're gone, that melody shall forever remain in my heart. For never again shall I find a pet so tailor-made for my delight, and fashioned so exquisitely for my love.

*Love,*
*PJ*

**Beth Ostrosky Stern:** *Bella*

*Dear Bella,*

You can't see me. You can't see your food, your bed, or the birds outside the window. You can't see your toys, the Christmas tree, your three brothers and sister. You can't see your dad. And you can't see the beauty that surrounds you. You tilt your head up at us with your heartbreaking face, with your eye that can only see shadows, and leave us wondering. Oh sweet, beautiful Bella . . . How did you lose your eyesight? My husband and I say that we wish we could wave a magic wand and give each of our five rescued cats a few minutes to talk so we could hear their stories. But maybe it's a blessing that it's not possible, for it might be too painful to hear.

I will never forget the day I was at North Shore Animal League America's rescue and adoption center and saw you for the very first time, a blind, pregnant cat rescued by NSALA from a high-kill/overcrowded municipal NYC shelter. When I met you, you had already given birth to four perfect kittens. If only you could see what beauties you gave birth to, sweet Bella.

But I couldn't let you go and brought you home. My four cats fell in love with you. You mastered every room in our big house. You ate so gracefully; not a morsel of food ever fell out of your dish. You never missed your litter box. And you found every cat bed in the house. You made it clear you were home. But in my heart I think we already knew that . . .

We welcome you to our family, sweet Bella Stern. You will be safe and cared for through the rest of your life. I vow this to you. I only wish you could see the love I have in my eyes for you. But somehow I know you can feel it.

Whenever I have one of those days where I'm not in a good mood, or my jeans are a bit tight, or my hair isn't looking the way I like, I look at you, beautiful girl. Despite what you look like or the cruelty that was inflicted upon you, you continue to have strength and a happy, sweet spirit. I've learned so much from you!

You are a survivor. Now relax, sweet girl, and enjoy the life you so deserve. You found your way to our happy, safe home. Thank you for you. You are a blessing. Sweet Bella Stern. You are loved.

*Love,*
*Beth*

*To my children:*

I never thought I was a cat person. I never thought I was a dog person.
I can't even keep a goldfish alive. But when we brought you two home
six years ago . . . you kitties rocked our world. Two little sickly, adorable
creatures . . . who could not be more different from each other.

Mr. Spock: You are heaven. My heaven. You are human. You are a lover.
You look at me every moment of every day and remind me that my capacity
to love is boundless. You are so funny. We play catch. Really. Do you think
you are a dog? Your face is flat like a furry pancake and your purr is like a
sixties Chevrolet. You make everyone laugh. You literally sit at my feet on the
toi toi. You sleep in my arms and dream with me. Your magic is contagious.
You are spectacularly beautiful and you know it. You have attitude and poise
. . . and kindness. Never a scratch . . . never a shriek. I want to be you when I
grow up.

Ida: You are an old lady. You are timid. You hide. Mr. Spock pushes you
away from your shared bowl of food. I feel your sadness. I feel your isolation.
You were born an old soul. You are beautiful. And you are complicated. Like a
jigsaw puzzle with missing pieces that will never all align themselves. And for
that, for your uniquely genuine soul and spirit, you are loved more than you
will ever know. We have a lot to learn from you.

Mr. Spock and Ida . . . you are our children. We never had humans. But is
there a difference? We would argue not. Love is love. We are forever bonded
to you, our children . . . bonded by love and gratitude for you two gorgeous
creatures that share our lives. You changed us. We are changed.

*Love,*
*Mommy*

*Dear Gemini,*

I'll never forget the first time our eyes connected. It was fifteen years ago that I flew out to Jacksonville, Florida, to meet my new girlfriend's parents. You were staring into my eyes, pawing me, and being very vocal. I said, "Wow, this cat is awesome . . . it's trying to tell me something!" My girlfriend's father then told me he was getting rid of you because they were moving out of the state. Getting rid of you? What does that mean, I thought?

Well, the next morning I told them I wanted to take you with me back to California. They didn't believe me at first and thought I was a little crazy, but sure enough I sneaked you on the plane with me. During the flight you managed to escape from your bag and took off running all over the plane. The plane was filled with female high school soccer players and all the girls were going crazy as you were jumping on all their laps. If you weren't so adorable I'm sure I'd have been arrested upon landing in L.A.

Since then, I've been so happy to see your big bright blue eyes when I come home. Granted, I thought you would help get rid of mice, but instead you catch them outside and release them into the house. But that's because you're so nice. You don't kill anything.

I feel like you are on a higher level than a lot of other felines. After all, you are from an amazing breed of cats that belonged solely to kings and queens of Thailand, then known as Siam. You've made me love and respect Siamese cats. Whatever the case may be, THANK YOU for spending your life with me and giving me so much love and joy.

*Love,*
*Jimmy*

**Kristin Bauer van Straten:** *Abigail and Samuel*

*Dear Abigail and Samuel,*

Samuel, after I lost my Scrappy, I went to the rescue for many months looking for that connection again. The first time I held you, my eyes welled up and your dad knew you were the one coming home with us. I'd finally found you. I love how talkative you are, how you have to cuddle with the dogs, how you covet my socks, and how even though you're twice Abi's size, you wrestle with her fairly.

Abigail, after we adopted Samuel, your foster mom told us, "He has a sister," and your dad and I said, "Well, we'll take her too." When we came back to pick you up, all one pound of you, I'll never forget when I put you in your dad's big hands and he became a puddle. You had one eye half open, a crooked tail, feathers for fur, and parasites . . . but you healed and grew into the most fearless, optimistic, and happy creature I have ever known.

Every day I am thankful for you both. Abi, you still have your father wrapped around your tiny paw, and Samuel, you're my big beautiful tomcat.

*Mom, Dad, Asher, and Ozmund*

P.S. Peeing on the dog bed will never make us feed you more.

*My dearest Piaf,*

I wish I were more like you.

You love without judgment, criticism, or selfish intentions.

You carry no residual feelings or opinions of anything regarding the past or the possible future.

The one time I accidentally stepped on your tail, your physical body reacted, but you shook it off in a heartbeat, and moments later we carried on as if nothing had happened.

You didn't even see a need for forgiveness . . . That is how perfectly enlightened you are.

My sweet little sparrow, I adore you.

*K. V. Drachenberg*

**Dita Von Teese:** *Aleister*

*Dearest Aleister,*

You know I was always more of a "dog person" until I met you . . . and I wasn't sure about you at first. When you were a kitten, your ears were too big and you were molting, so you didn't have much fur. Your gray, leathery skin prompted me to call you "The Bat," which is still my favorite pet name for you. Not just Bat but THE Bat. With your wavy fur, wide-set eyes, and huge ears, your bizarre beauty is striking. Everyone asks "What kind of cat is that?" Oh, this is a very special cat, indeed!

Everyone who knows you agrees that you're no ordinary cat, and even "dog people" can't help but get excited when they get to see you. Even people who have their own cats admit that you are really the *best cat in the world.* You play fetch properly. You hear the key in the door and always come running to greet me. If you hear a sound in the house, you get up and go see what it is. You've flown all over the world, and you love staying in hotels with me. You have hung out backstage at my shows. We lived in Paris together.

Yes, you can be naughty sometimes . . . like the time you stole and dragged an entire roasted chicken across the kitchen floor, or the way you wake me up by tap-tap-tapping my forehead with your paw. And I admit that I can't help but secretly love it when you use someone's blue-jean-clad leg as a scratching post. This cat doesn't care for jeans. This is a cat who stands for glamour.

You're a force to be reckoned with . . . Angelina Jolie was actually afraid of you when she met you! You're an art muse. Your unusual beauty and dynamic personality have been captured by some of the best artists and photographers in the world. You've been published in countless magazines. You've got thousands of followers on Instagram. You've got your own theme song. Your visage has been tattooed. What other cat can claim all that?

You're lovable with everyone, which sometimes makes me jealous, but what I love best is that you're so very tolerant of my overcuddling of you. I love the way your facial expressions change and the way you drool and gently snore when you're really relaxed. You're a cat with a big personality that changes people's minds about cats, and I love you!

*Love,*
*Dita*

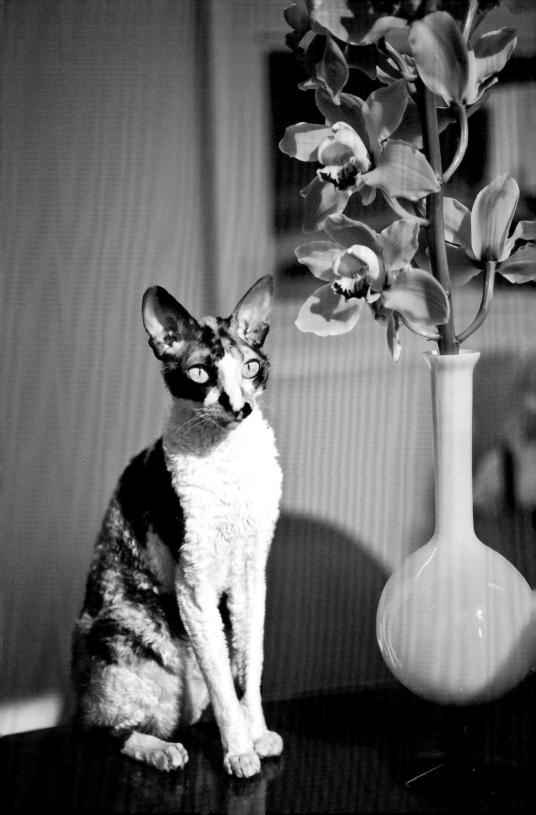

*Dear Mouse,*

I remember the first day I saw you. You looked like a weird little combination of a mouse and a bat with a creepy tail that looked like a snake. The first words out of my mouth at seeing you were, "WTF is that?"

WTF you are is a sometimes annoying, spoiled, and sweet cat that I love more than anything in this world (sorry, my pet bird Buttwings, it was you once, but after you almost bit off my lip our relationship changed). I take you to work and you always pee in the bag, which is so nice of you and makes my morning drive to work so pleasant! You also pee around my house, especially on expensive sweaters (maybe I shouldn't leave them on the floor???). You wake me up at all hours of the night so I can give you a treat. But nothing is better than, as soon as I turn out the lights, having you cuddle up right next to my face and waking up with you still there. The only thing that makes me happier than you being my cat is me being your human.

*Love,*
*Mommy*

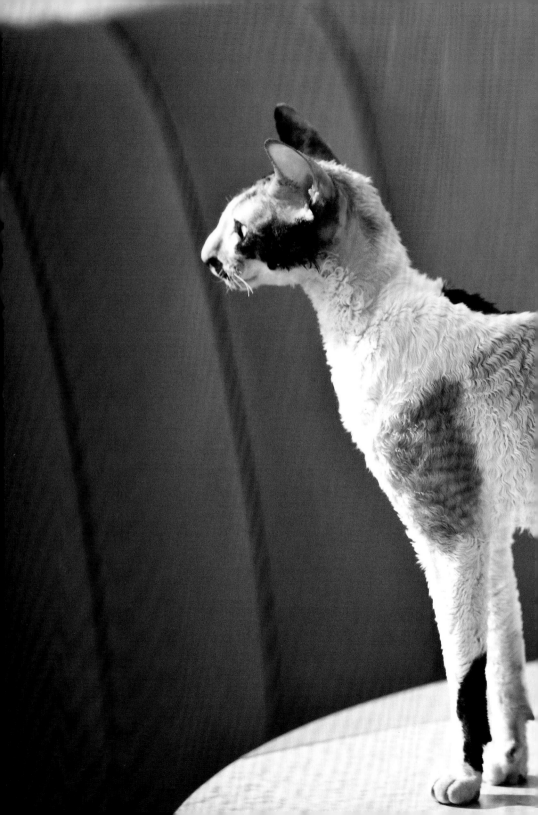

**Amanda Welter:** *Ollie*

*Dear Ollie,*

I hope this letter finds you well and that you have recovered from your stressful day guarding the fish. You are doing great. Keep up the good work.

I wanted to let you know I found the present you left me this morning at the foot of my bed. I'm sure that mouse had it coming! Please don't take offense that I didn't enjoy him quite as much as you—it's the thought that counts. In fact, as a reward for all your hard work and dedication I have a very special gift for you! Fresh catnip!! Just please try to control yourself—I don't want to find you digging chicken scraps out of the garbage disposal like the last time . . .

Before I go, you'll be very happy to know the dog had a trip to the vet today. Feel free to relish the thought of his discomfort.

Well, dear friend, I hope this didn't take away any of your precious sunbathing time. Carry on!

*Love,*
*Mom*

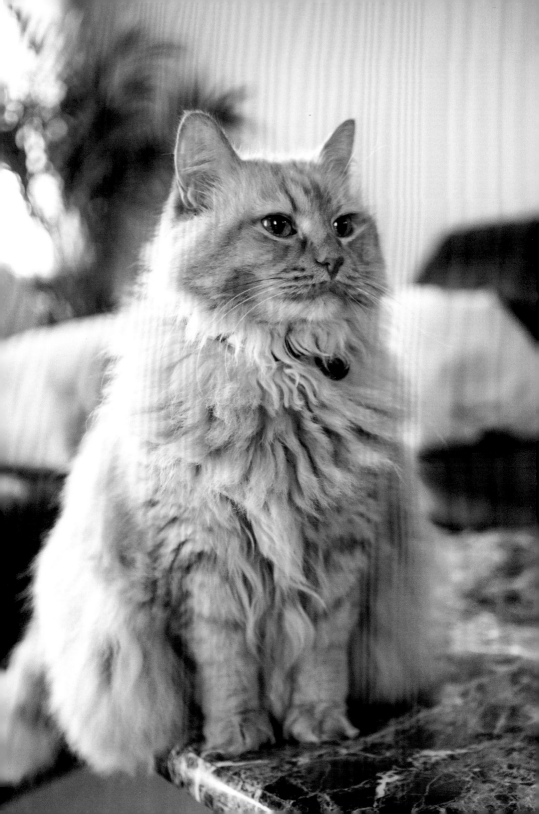

Dear Mittenz,

Here are the top five reasons you let me live with you:

5. I needed a new couch. Thanks for making it happen.

4. Those pesky bills and letters on my desk needed to be filed again.

3. I need to get up at 2 a.m. anyway . . . I may as well let you in.

2. You bring me such interesting items . . . birds, lizards, rats, mice . . .

1. You are the most handsome of cats and you look really good in a tuxedo.

Faithfully yours,
Fred

Meet the Family

**Rosanna Arquette & Luna**  Actress, director, and producer Rosanna Arquette is known for her memorable performances in film and television, including a Golden Globe–nominated role in the cult hit *Desperately Seeking Susan.* Thirteen years ago, Rosanna and her daughter, Zoe Blue, found abandoned Luna at a kitten hospital. Luna quickly became Zoe's little lamb, following her everywhere. After Zoe left for college, Luna changed her tune and became the lion queen of the house, ruling the land with her loud and frequent meows and human-like chatter. When Zoe comes home on school breaks, Luna again becomes a little lamb who only has eyes for her.

**Anne Marie Avey & Colonel Meow**  The rags-to-riches tale of Colonel Meow began when he was abandoned on the side of the road in Washington and then rescued by Seattle Persian and Himalayan Rescue. When Anne Marie Avey adopted him, little did she know that her furry new friend would soon be a Guinness World Record holder for the cat with the longest fur (nine inches!). Sadly, Colonel Meow passed away at age three in January 2014 after battling a heart condition.

**Tony Azevedo & Snow**  Tony Azevedo is an American water polo player who has competed in four Olympic Games and currently serves as the captain of USA Water Polo's Men's Senior National Team. His skills in the water proved to be life- saving two years ago in Montenegro, when he rescued a cat that a group of boys had thrown into the water to drown. He brought the cat, named Snow, back with him to the United States, and the experience encouraged him to speak out about animal rights and overpopulation.

**Ellie Barancik, Francis & Ollie**  Ellie Barancik is an Emmy-nominated comedy writer and producer for numerous television shows, including *The Bonnie Hunt Show* and *Late Night with Conan O'Brien.* While working for Conan, she found herself frequently writing comedy pieces involving kittens, leading her to eventually adopt Francis and Ollie. She chose them from a litter of seven kittens in foster care in New Jersey, and the two lovable weirdos have been a source of joy ever since.

**Erica Berse & Jill**  The "Hang in There, Baby" inspirational cat poster might have been made for Erica Berse's courageous kitty, Jill. A true survivor, this fierce feline remains happy and affectionate despite losing a leg to bone cancer and suffering through four rounds of chemotherapy. Jill now spends her days patiently waiting for Erica to return from her job in the recruiting department of a Manhattan law firm so they can enjoy some serious snuggle time, which is Jill's favorite cat activity in the world.

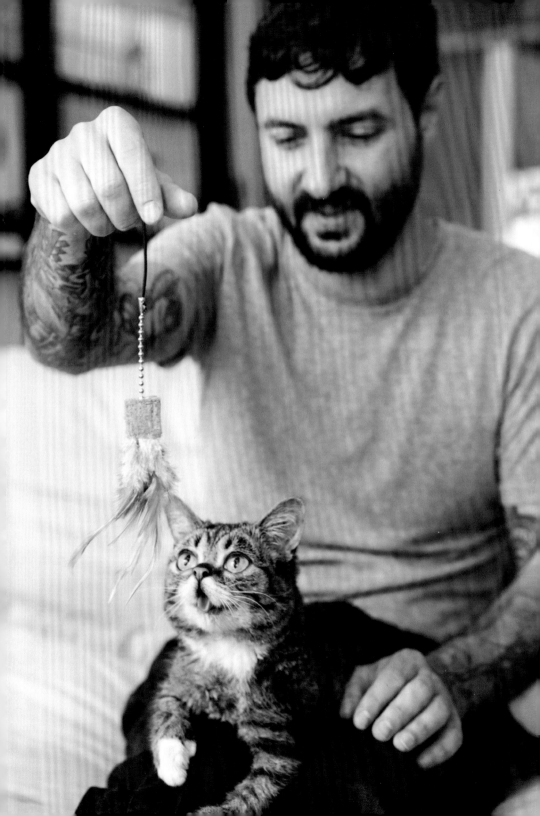

**Mike Bridavsky & Lil BUB**  When Mike Bridavsky first set eyes on this little runt of the litter, he knew he'd found love. Born with several genetic mutations and needing to be bottle-fed, this tiny gem was one of a kind. Mike picked her up and said, "Hey, BUB"—the words that marked the beginning of a beautiful relationship. Mike took Lil BUB home and before he knew it, this little perma-kitty had turned into a giant star. Lil BUB has appeared on *Good Morning America*, *Today*, and *The View*. She and Mike created Lil BUB's Big FUND for the ASPCA, a national fund for special-needs pets.

**Anne Burrell & Puddy**  Anne Burrell is an American chef and a Food Network star, hosting numerous shows, including *Secrets of a Restaurant Chef, Worst Cooks in America*, and *Chef Wanted with Anne Burrell*. Anne is also the author of *Own Your Kitchen*, as well as the *New York Times* bestseller *Cook Like a Rock Star* . . . but the biggest rock stars in Anne's life are her two favorite felines, Puddy and Nancy.

**Lauren Caltagirone, Harris & Austin**  When Lauren Caltagirone found herself frequently leaving work early to go home and spend time with her adopted cats, Harris and Austin, she realized it was just the first of many "Single Girl Cat Lady Problems." There are many, and they are funny. Thus, an Internet personality was born, and now you can follow Lauren's kitty-fueled trials and tribulations on Twitter at @mrsrupertpupkin. True story: Harris once meowed so loudly that Lauren's shoe fell off.

**Gregory Castle & Bullfrog**  Gregory Castle is the cofounder and CEO of Best Friends Animal Society, a national nonprofit that collaborates with rescue groups and shelters to save dogs and cats in shelters across the country. A key leader in animal welfare, Gregory currently lives in Kanab, Utah, with his wife, Julie, and their family of cats and dogs. His cat Bullfrog is a shy little fellow. He always hides when visitors come his way—exactly why only Bullfrog knows—but when not hiding, he is a big tuxedo charmer.

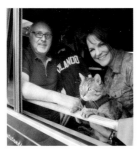

**Rick and Jennifer Chap & Buddy**  Ever since Buddy helped save Rick Chap from sudden cardiac arrest, Rick and his wife, Jennifer, have become passionate CPR advocates, using their incredible story to inspire others to learn CPR and take action to save lives. Rick also serves on the Orlando Health Heart Institute Patient Family Advisory Council at the hospital that provided his critical care. The couple lives in Orlando, Florida, with their beloved crew of rescued cats: Buddy, Rusty, Maggie, Sqeakers, Sabrina, and Tippy (the neighbor cat who visits every day!).

***Alice de Almeida & Matilda*** Matilda is the current resident cat at the Algonquin Hotel in New York City, continuing a tradition that began in the late 1930s. Matilda oversees the comings and goings of guests from all over the world. Each year Matilda is given a birthday party befitting a Big Apple celebrity, which raises money for local animal shelters. She spends most of her day responding to fan mail with help from Alice de Almeida, who serves as the executive assistant of the Algonquin, but more important, as Matilda's Chief Cat Officer, who fortunately has opposable thumbs.

***Mark Degenkolb & Lucki*** Mark Degenkolb is a talent manager and television producer who runs his own company, Degenkolb Entertainment. When he is not busy surfing or spending time with his wife, Diana, and daughter, Dori, Mark can often be found playing with Lucki, whom he describes as a "cat-dog" because of her doglike personality. Lucki has even appeared on television to demonstrate her unique leash-walking ability, outgoing personality, and general awesomeness.

***Grace Dennis & Timmy*** Grace Dennis is a Los Angeles fourth grader whose sleepy cat, Timmy, had been around her entire life. Still, they weren't always real friends. It was only when Grace spent some time away from home that Timmy realized how much he missed her. Now they are buddies and love hanging out. Timmy loves to eat, especially people food, but Grace does not appreciate when he eats the cream cheese off her bagels.

***Paul DiGiovanni & #cat*** Paul DiGiovanni is a songwriter and the lead guitar player for the pop rock band Boys Like Girls, known for their three bestselling albums, including 2009's *Love Drunk,* which debuted at number one on the *Billboard* Top Rock Chart. Given the band's major presence on Facebook and Twitter, it is only appropriate that Paul has given his favorite feline the name "#cat," using the popular hashtag symbol found on social media. #cat's favorite hobby is eating. #dadsdinner #everynight #imtoocute #hecantsayno

***Lenay Dunn & Paisley*** Lenay Dunn grew up making quirky videos with her friends, and her taste for on-screen adventure eventually led her to the energy drink company Red Bull, where she starred in, edited, and produced several hit web series, such as *Red Bull Roadies* and *Can You Make It?* She currently works for MTV (where she hosted the show *10 on Top*) and was also the face of Macy's American Rag brand. She lives in New York with her husband, Jason Dunn, the former front man of the band Hawk Nelson. Her cat, Paisley, is the real star of this family, though. She thinks she's a dog half the time, and when she's not chasing her tail or taking naps atop Jason's sandals, she is sneaking up and jumping on her older pug brother, Murphy.

**Jackson Galaxy & Velouria** Jackson Galaxy, aka "The Cat Daddy," is a celebrity cat behaviorist and the host of Animal Planet's hit show *My Cat from Hell*. His memoir, *Cat Daddy: What the World's Most Incorrigible Cat Taught Me about Life, Love, and Coming Clean,* describes the origin of his mission to make the United States a no-kill country and help save the millions of dogs and cats who die in animal shelters each year. Jackson currently lives in Los Angeles with his dog and nine cats (six house cats, three feral), including his beloved rescue cat Velouria (not the cat from hell—whew!).

**Jason Gann, Sydney & Tokyo** Jason Gann is a writer and producer who is best known for his role as the title character, a talking dog, in the comedy television series *Wilfred*. Jason spends his time offscreen working as a spokesperson for the Los Angeles–based animal rights group Stray Cat Alliance and gives credit to his cats—Sydney and Tokyo—for helping him stay sober.

**Mayte Garcia & Willy** As the owner of seven dogs, two cats, and five birds, Mayte Garcia is the ultimate animal lover. This dancer, actress, singer, and former wife of pop star Prince recently appeared on Lifetime's *Army Wives* and is a regular cast member on VH1's *Hollywood Exes*. Her two rescue cats, Willy and Sashyra, like to spend their time terrorizing her dogs and running the animal-filled house. Mayte is also the founder of Mayte's Rescue, a nonprofit that finds loving homes for shelter dogs and cats.

**Claudene Garmon & Charlie** Claudene Garmon met Charlie in a cat-petting program she started at the local animal shelter, which recruited volunteers to help pet, brush, and spend time with shelter cats until they found homes. She eventually adopted him and helped him become a certified therapy cat. Claudene is a retired special education teacher who lives in Coronado, California, with her husband and their three felines. She runs the Trap-Neuter-Return program for Coronado CARES, an animal rescue organization.

**Gina Gershon & Cleo** When Gina Gershon lost her beloved cat Cleo, the outrageous and entertaining search for the cat proved to be the inspiration for Gina's book *In Search of Cleo: How I Found My Pussy and Lost My Mind*. The pair were eventually reunited, and Cleo remains one of Gina's true loves, waking her up with kisses each morning. The actress, known for her many roles in film and television and on Broadway, has also released a young adult novel she wrote with her brother called *Camp Creepy Time,* as well as a music album titled *In Search of Cleo* and a kids' record called *The Good, The Bad, and The Hungry.*

**Fiona Gubelmann & Bijou** Fiona Gubelmann rescued Bijou after taking one look at her milky white cataract-ridden eyes and knowing she would have difficulty finding a good home. At first, Bijou was not welcomed by her kitty siblings, Dragon and Tigerlily, but over time she won their hearts. Fiona is a Los Angeles native best known for her role in the FX series *Wilfred*.

**Karen "Doc" Halligan & Kinky Girl** Dr. Karen Halligan is a renowned veterinarian, author, national authority on animals, and currently the chief veterinary officer for the Lucy Pet Foundation. "Doc" Halligan's cat, Kinky Girl, was rescued by a veterinary technician at her office. Kinky Girl was a skinny stray, and Doc Halligan immediately fell in love with her. Kinky Girl travels across the country with Doc to let children everywhere experience the unconditional love of a cat.

**Laureen Harper & Gypsy** Laureen Harper, wife of the Right Honourable Stephen Harper, prime minister of Canada, is passionate about animal welfare. She is a volunteer with humane societies across Canada, as well as a foster mom to kittens awaiting placement in forever homes. The Harper family wouldn't be complete without furry felines Gypsy and Stanley, and Charlie, a chinchilla, all of whom were rescue animals. As the oldest and wisest of the Harper pets, Gypsy rules the roost.

**Mariel Hemingway & Señor Mow** Granddaughter of the famous novelist Ernest Hemingway, Mariel Hemingway is an author and actress best known for her Academy Award–nominated role in *Manhattan*. A writer, healthy-living enthusiast, and advocate for mental health awareness, Mariel is the author of the 2013 book *Running with Nature,* which offers steps on how to live a healthier and a more fulfilling life. Mariel says she finds her greatest fulfillment through her relationship with her beloved kitty, Señor Mow, who happens to share Mariel's love of the outdoors.

**Paige Hemmis, Mercury, Eros & Simba** Despite a lack of formal training, Wisconsin-born Paige Hemmis is an accomplished home builder and gifted carpenter. Her innate talent led to her role as a designer on ABC's *Extreme Makeover: Home Edition.* When she's not wielding a toolbelt, you can find her at home with her three extremely cool cats: Eros and Simba (a pair of Highland Lynx brothers) and Mercury.

**Sarah Hepola & Bubba**  Sarah Hepola is a former newspaper editor and currently the personal essays editor at Salon.com. Her stories have appeared in *The New York Times Magazine, Glamour, Slate,* the *New Republic,* and the *Morning News,* where she has been a contributing writer for more than a decade. Her marmalade tabby, Bubba, makes an adorable "snarl" when his upper lip gets caught on the spot where he is missing a front tooth.

**India Hicks & Gloria**  India Hicks discovered her cat Gloria as a tiny abandoned kitten shivering in a wet tree during a summer rainstorm. Given that tumultuous beginning, it is no surprise that Gloria can be a little rough around the edges, but she has still become a beloved part of a family that includes India, her partner, their five children, and numerous animals of all shapes and sizes. They live on a small island in the Bahamas, where India designs collections of bedding, jewelry, and fine fragrance sold globally through IndiaHicks.com. She has also published two books, with part of the proceeds donated to a small nonprofit community school in the Bahamas.

**Carrie Ann Inaba & Taz**  Although Carrie Ann Inaba rescued her two cats—Squeeker and Taz—from a shelter, she believes that they have truly rescued her. Carrie Ann is a singer, dancer, and actress who currently serves as one of the judges on the ABC hit *Dancing with the Stars.* Carrie Ann spent most of her childhood on a wildlife preserve in her native Hawaii and has devoted much of her adult life to caring for animals. In 2012, she cofounded the Carrie Ann Inaba Animal Project, which is dedicated to supporting the rescue, welfare, and well-being of animals.

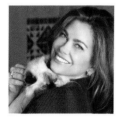

**Kathy Ireland & PG**  In addition to making a record thirteen consecutive appearances in the *Sports Illustrated Swimsuit Issue* (three of them on the cover), and being named *SI*'s greatest cover subject of all time, Kathy Ireland developed her company, Kathy Ireland Worldwide, into one of the world's most powerful designer brands. Kathy uses her influence to support a vast array of charities and non-profit organizations. Her cat, PG, is a rescue Himalayan fond of cuddling for hours at a time.

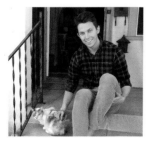

**Alex Jeffries & Hova**  Alex Jeffries and his girlfriend, Glory Gale, rescued their cat Hova as a stray, and although she has gradually grown accustomed to a life indoors, she has never quite shed her conniving and mischievous personality. Hova loves bird-watching and taking wild romps through piles of freshly dried laundry. Alex is a writer and television producer who has worked on a variety of shows, including *The Ellen DeGeneres Show* and *TakePart Live.*

**Dr. Rachel Jones & Gia** Gia came to Dr. Rachel Jones hurt, scared, and dying, and emerged as an "ass-kicking gangster cat" who survived a terrifying ordeal in which she was struck by a car and then went into respiratory arrest during surgery. Now fully recovered, Gia loves sleeping on top of Rachel at night while listening to Snoop Dogg. (Just kidding—she prefers Cat Stevens.) After several years of private practice, Rachel opened the Marina Veterinary Center in Westchester, California, where she offers her animal patients both holistic and traditional treatment.

**Dr. Betsy Kennon & Scooter** With a crushed vertebra and no movement in his hind legs, Scooter seemed destined to be euthanized when he was brought in to Dr. Betsy Kennon's veterinary office more than five years ago. But something about the paraplegic cat convinced Betsy to save him, and the two have become a dynamic duo, visiting hospitals and nursing homes to bring happiness and encouragement to the patients. The aptly named Scooter scampers around in his custom-made wheel cart, eliciting smiles wherever he goes. Betsy lives in Pittsburgh with her husband, Steve, and their cat, four dogs, several fish, and a bird.

**Jesse Knott & Koshka** Jesse Knott is a former staff sergeant in the United States Army who first met Koshka while stationed in a small village in Afghanistan. He saved the cat from a life of abuse, and Koshka repaid the debt by comforting Jesse through some of his darkest times. After making the long and challenging journey to the United States, Koshka settled into a happy home life with Jesse's parents in Oregon, where she still lives today. The ASPCA honored Koshka with their Cat of the Year award in 2013.

**Liz Kozak & Phillip** Liz Kozak is the editor in chief of The Second City Network, the online extension of the world-renowned comedy powerhouse The Second City. She lives in Chicago with her husband and daughter and their two cats, Phillip and Eleanor. Phillip's hobbies include getting wedged behind the washing machine and eating toilet paper. Liz's hobbies include un-wedging cats from behind washing machines and toasting toilet paper squares on the panini grill.

**Nina Laden & Cali** Nina Laden is an award-winning, best-selling children's book author and illustrator who lives in Seattle and on Lummi Island, Washington, but mostly she lives in her imagination. She has over a dozen books in print, including *The Night I Followed the Dog, When Pigasso Met Mootisse, Roberto the Insect Architect, Peek-A Who?*, and her latest book, *Once Upon a Memory*. Nina also visits schools and libraries and loves to inspire children and adults to be creative. Sadly, her beloved cat Cali passed away in December 2013.

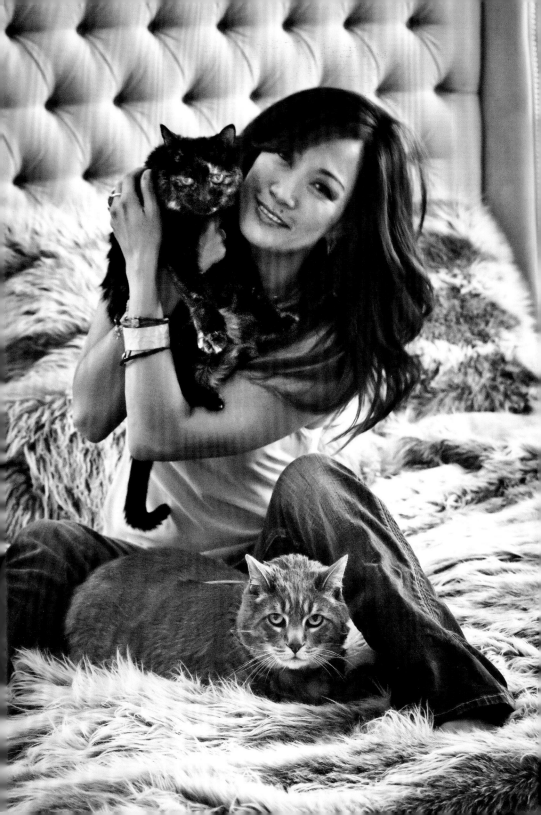

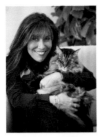

**Lisa Lillien & Jackson**  Lisa Lillien's *Hungry Girl* empire began as a free daily e-mail about better-for-you eating and has since exploded into a massive brand. The e-mails, which are packed with diet advice and recipes, now go out to more than 1.2 million subscribers. She is a *New York Times* best-selling author of nine books (and counting!), and her *Hungry Girl* television show airs on Food Network and Cooking Channel. Lisa lives in Los Angeles with her husband, Daniel; dog, Lolly; bunnies, Cupcake, Tosie, and Spencer; and beloved and well-fed Maine Coon rescue, Jackson.

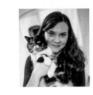

**Stacy London & Al**  Stacy London, host of the popular and long-running TLC hit *What Not to Wear,* is one of the country's most sought-after style experts. When Stacy isn't spotting the latest trends in fashion, she's curled up on her couch with her favorite furry accessory, her beloved cat of seventeen years . . . Al.

**Kady Lone & Pudge**  In 2010, Kady Lone drove from Minnesota to Chicago to adopt Pudge. From that point on, Pudge was most content when Kady carried her tiny body cradled in one arm like a newborn baby. Kady loves her cat's beautiful coloring so much that Pudge now has her very own—and very popular—Instagram account.

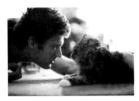

**Brook Lopez & Poupin**  As a seven-foot-tall professional basketball player, Brook Lopez often finds himself towering above his surroundings, so when he noticed a large cat standing out from all the others at a PetSmart in California, he felt an immediate connection. He decided to adopt Poupin, but soon found that he would be living under Poupin's rule, not the other way around. Brook is the starting center for the NBA's Brooklyn Nets. He was named to his first NBA All-Star team in 2013, but his accolades haven't stopped Poupin from waking him up at all hours of the night to do his bidding.

**Maggie McEneny & Pyewacket**  Maggie McEneny, a life-long cat lover, drove eighteen miles through a blizzard to rescue Pyewacket when the little furball was just twelve weeks old. Pyewacket is now most happy staying home for a good game of hide-and-seek. Maggie is a former police officer and national park ranger, and currently works for Metro Transit in Minneapolis/St. Paul.

**Wendi McLendon-Covey & Carmen**  Not only did Wendi McLendon-Covey play a "cat lady" on CBS's *Rules of Engagement,* the actress owns four cats of her own (all rescues). Carmen, the only one brave enough to show her face in front of strangers for a photo shoot, passed away in January 2014. Wendi is best known for her hilarious acting roles in ABC's *The Goldbergs,* the hit comedy *Bridesmaids,* and Comedy Central's *Reno 911.*

**Georgia Minnis & Snowball** Georgia Minnis is a fourth grader at Los Feliz Charter School for the Arts in Los Angeles. She received Snowball, a Siamese and Maine Coon mix, as a Christmas present from Santa in 2012. Georgia is delighted by Snowball's love of bacon and bathtubs.

**Melissa Lemer Mogel & Pusswah** Asked to pick the one thing she loves most about her cat, Melissa Lemer Mogel doesn't hesitate to point out Pusswah's walk. The cat's short legs don't prevent her from having a runway-caliber strut and supermodel attitude. Melissa, born and raised in Los Angeles, is the original creator of "gifting suites" at celebrity events. She lives in the Hollywood Hills with her husband, Andy, and their two sweet furry babies, Pusswah and Allen Gregory.

**Lisa, Clark, Ava, and Grant Morin & Obi** Lisa Morin is a longtime television producer and consultant who has worked on a variety of shows, including *The Oprah Winfrey Show* and Anderson Cooper's daytime talk show. She lives in Sherman Oaks, California, with her three children, Clark, Ava, and Grant. Even though their cat Obi, a Tonkinese, was considered a "breeder reject" because of his broken tail, the family adopted him as the perfect cat for them. He's been breaking hearts with his good looks ever since.

**Dr. Mehmet Oz & Baby Cat** Dr. Mehmet Oz is the host of the five-time Daytime Emmy Award–winning *The Dr. Oz Show,* now in its sixth season and seen in 118 countries. He is also a renowned author and surgeon who performs more than one hundred heart surgeries each year. Dr. Oz lives in New Jersey with his wife, their four children, and numerous pets, but the family's Siberian—affectionately called Baby Cat—rules the roost. Although Baby Cat likes to make his presence known by playfully tormenting the other animals, he has a soft side as well, often sharing a bed with the family's dog, Rosie.

**Sasha Perl-Raver & Swayze** TV personality Sasha Perl-Raver says the greatest love of her life came in the form of a homeless and disabled Siamese kitten. Little Swayze wobbled into Sasha's heart four years ago, and on that day both of their lives were changed forever. Sasha says her furry soul mate reminds her of a cinnamon roll fresh out of the oven . . . warm and yummy. Sasha starred in the Food Network's *Private Chefs of Beverly Hills* and is now the host of *FX Movie Download.*

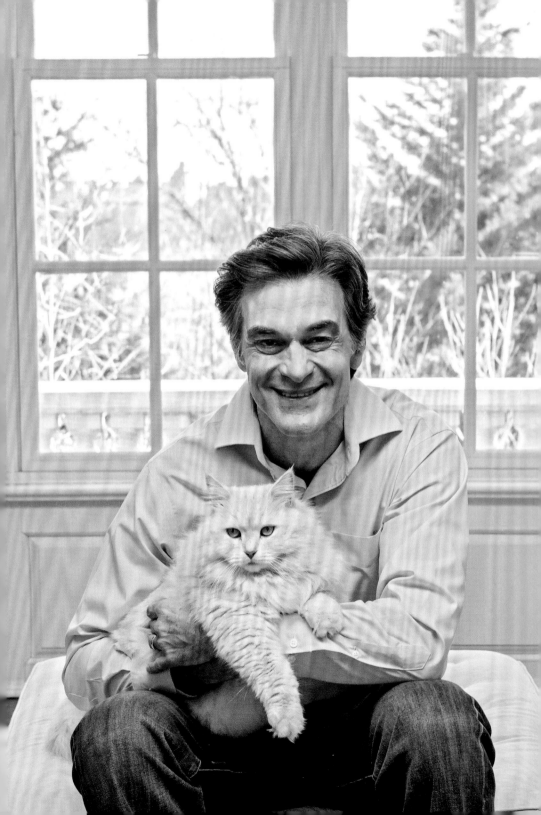

**Joe Perry & Icon** Aerosmith rocker Joe Perry always considered himself a dog person, but it didn't take long for Icon—a huge and magical Maine Coon—to change his mind. Joe and his wife, Billie, love animals of all shapes and sizes, and the couple helped fund the construction of a new animal shelter near their home in Massachusetts. They are also heavily involved in the Friesian horse community, working to raise awareness for a species that was recently considered endangered.

**Lisa Ray & Coco** Lisa Ray's cat, Coco, was a fortieth-birthday present from her loving husband, Jason. She describes Coco as "the feline version of Angelina Jolie" and created a theme song titled "Coco-girl" that she sings to her each morning. Lisa started her career in Mumbai in the early '90s and has since gone global. She's a model, actress (starring in the Academy Award–nominated film *Water,* among other international credits), social activist, and currently the host of Canada's hit show *Top Chef Canada.* In 2009, Lisa was diagnosed with multiple myeloma. She says Coco is a source of comfort and joy as she continues to fight cancer and live each moment to its fullest.

**Dr. Monica Revel & Toast** Dr. Monica Revel is a veterinarian and the owner of West Hollywood Animal Hospital. She has performed over twenty thousand spays and neuters for animal shelters in the Los Angeles area. Her cat, Toast, comes to work with her every day. She has earned the nickname "The Pain Police" because of her tendency to rush toward any dog or cat she hears crying to make sure they are okay. Monica is also the proud owner of two other rescues: a Great Dane and a potbellied pig.

**Michelle Salas & Valentino** The daughter of singer/actress Stephanie Salas and iconic Mexican singer Luis Miguel, Michelle Salas is a contributor for *Hola!* magazine and a fashion blogger for www.stereotypemess.com. She currently lives in L.A. with her cat Valentino, named after the legendary Italian fashion designer. Valentino is incredibly social and quite fashionable himself, sporting a haircut that makes him look like a miniature white lion.

**Kimberly Schlapman & Sugar** Kimberly Schlapman graces the stage as a member of the Grammy-winning country foursome Little Big Town, and the screen with her hit cooking show, *Kimberly's Simply Southern.* Music, family, and food are what make this Southern belle bloom, but her life was not complete until her sweetie, Sugar, pounced through the door.

**Stephen Simmons & Burma**  Stephen Simmons is a veteran of the United States Army who served with the 29th Infantry in the Iraq War. After returning in 2008, he had difficulty re-adjusting to civilian life and eventually found himself living in his Jeep in the foothills of Oregon, with his dog, Puppi, and his adventure cat, Burma. With determination to overcome his current situation, Stephen used a cell phone camera to take thousands of photos of their rugged adventures, which were compiled into a book, *The Adventures of Puppi & Burma,* to help raise awareness for homeless veterans. A second book, focusing on Burma, is due out in late 2014.

**Amy Smart & Nala**  Although she grew up with a pet dog and a pet bird, Amy Smart always wanted a cat, so one of her first moves after getting her own apartment was to adopt two little kittens. When her black cat, Nala, isn't busy chasing bugs or stalking his bulldog "brother," Slim, he loves sleeping in Amy's lap. Amy is an actress known for a wide range of roles in both television (*Felicity, Shameless, Justified*) and film (*The Butterfly Effect, Just Friends, The Single Moms Club*). She is an avid animal advocate, supporting organizations such as the Best Friends Animal Society and No Kill Los Angeles.

**Art Smith & Negrita**  Art Smith and his husband, Jesus Salgueiro, a painter, share their Chicago home with five wonderful cats and a trio of dogs. While these eight furry children are Art's anchor, his career takes him all over. From preparing meals for President Barack Obama to serving as Oprah Winfrey's personal chef, he has displayed his talent and passion for cooking Southern cuisine to some of the world's most famous people. He also owns and operates several restaurants across the country in addition to dedicating his time to multiple charities and organizations.

**PJ Smithey & Tinkerbell**  PJ Smithey is a Dallas-born and -bred painter and graphic artist who, at five years of age, met the feline love of his life—a rescue cat named Tinkerbell. She was brought to a shelter after she was abandoned by her mother at a country club tennis court, and sixteen years later, PJ and Tinkerbell are inseparable. When PJ left for college in Florida, Tinkerbell became so lonely that he would have to speak with her on the phone to soothe her.

**Beth Ostrosky Stern & Bella**  Beth Ostrosky Stern couldn't resist adopting blind Bella after first becoming foster mother to Bella's kittens. Beth is a model, TV personality, and animal activist who is passionate about rescuing and fostering kittens. She serves as a volunteer and spokesperson for North Shore Animal League America. Her famous husband, radio personality Howard Stern, shared his gift for photography by contributing the exquisite pictures of Beth and Bella in this book.

**Suzy Unger, Mr. Spock & Ida**   As the CEO of OMG Productions, a television production company, Suzy Unger needs to travel frequently, leaving her adopted cats, Ida and Mr. Spock at home. To ensure that she is never more than a click away from her feline friends, Suzy and her husband have installed "kitty cams" in their home to check on the cats' well-being when they are away. The cameras monitor every room, while a recording of Suzy's voice plays throughout the day for the cats to hear.

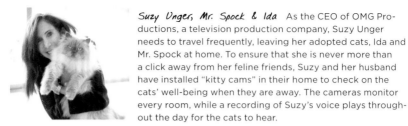**Jimmy Van Patten & Gemini**   Gemini stole Jimmy Van Patten's heart sixteen years ago and hasn't given it back since. After a harrowing flight from Florida to L.A., the duo have been living the Hollywood life. Jimmy is an accomplished actor, writer, and producer, known for a variety of roles in both film and television. He began his career as an actor at age twelve, appearing in more than thirty films and numerous television shows in four decades. He recently appeared as Dr. Heffner in the popular *Saw* horror franchise. Jimmy is also the spokesperson for his father's company, Dick Van Patten's Natural Balance Pet Foods.

**Kristen Bauer van Straten, Abigail & Samuel**   Best known for her role as the beautiful but lethal Pam in the HBO series *True Blood,* Kristin Bauer van Straten is a passionate animal rights advocate and loving owner of rescue kitties Abigail and Samuel. In 2011, Kristin partnered with the Animal Legal Defense Fund in an effort to free Tony, a thirteen-year-old Siberian-Bengal tiger who was caged as a roadside attraction at a truck stop in Louisiana. Kristin is also working with IFAW and the David Sheldrick Animal Trust to save the African elephant.

**Kat Von D & Piaf**   Every great artist needs a muse, and Piaf is happy to fill that role for Katherine Von Drachenberg (Kat Von D). Named after the influential French singer Edith Piaf, this hairless Sphynx cat was the runt of his litter and had to be bottle-fed, instilling in him the affectionate demeanor toward humans he still carries today. Kat is one of America's most talented tattoo artists, starring in the TLC show *LA Ink,* as well as a three-time *New York Times* best-selling author and the creator of a successful beauty line with Sephora. She runs both her gallery, Wonderland, and her tattoo shop, High Voltage Tattoo, in the heart of West Hollywood, California.

**Dita Von Teese & Aleister**  Inspired by the Golden Age of Cinema and vintage pinup imagery, Dita Von Teese began performing striptease in 1992 and developed into the biggest star in modern burlesque. With her glamorous demeanor and renowned fashion sense, Dita is credited with bringing burlesque back into the spotlight with a new sense of elegance. True to form, her cat, Aleister, is just as sophisticated, mingling with various celebrities while jet-setting around the world (in a Louis Vuitton carrying case, of course).

**Diane Warren & Mouse**  Diane Warren is one of the most prolific and successful songwriters of our time.  She has received six Academy Award nominations and is a Grammy Award and Golden Globe winner.  Among her many hits are "How Do I Live," "Un-Break My Heart," "Because You Loved Me," "I Don't Want to Miss a Thing," and "I Was Here."  Her Cornish Rex cat, Mouse, was given to her as a gift, and she loves her dearly. Mouse is Diane's faithful companion, spending each day with Diane at the studio while she creates her incredible songs, and maybe even inspiring a few.

**Amanda Welter & Ollie**  Part jungle cat and part social butterfly, Ollie enjoys destroying houseplants and hanging out with mom Amanda Welter while she gets ready in the morning. Ollie also never shies away from a lighthearted scuffle with her Chihuahua brother, Brix, usually taking advantage of her superior size to emerge victorious. Amanda works for the Target Corporation in Minneapolis.

**Fred Willard & Mittenz**  Mittenz has one house rule: he has to stay indoors at night. Unless, of course, he is attending a red carpet event with his famous dad, for which he is always ready with his tuxedo-style fur. Funnyman Fred Willard is a beloved star of stage, screen, and television. He has received Emmy Award nominations for his recurring appearances on TV's *Modern Family* and *Everybody Loves Raymond* and has been embraced by audiences for his roles in films such as *Anchorman: The Legend of Ron Burgundy, Anchorman 2: The Legend Continues, Wall-E,* and *Best in Show.* When not making our sides split, Fred, together with his wife, is committed to animal causes such as PETA, Actors and Others for Animals, and Farm Sanctuary.

# Acknowledgments

To the team,

It takes a village to produce a book. Thank you all for putting your love and passion for animals into every aspect of this project.

Ann Lofgren Satkoski—You are a star! I'm so grateful I get to work with you every day. I love that you gave birth to your own little "kitten" while creating this book!

Chelsea McMillan—Thank you for being there at the very beginning and helping bring this idea to life.

Zach Sundelius—You stepped in and brought your calm energy and great skills to our team when we needed you most.

Katrina Nicholson—Thank you for all the things you do to keep our team rolling and for being our main "cat whisperer" on the photo shoots.

Rachel Kent—First dog, now cat . . . thank you for all you do for alettertomydog .com and alettertomycat.com.

Peggy Fitzsimmons—Thank you for always helping to land the plane! You're the most amazing friend and collaborator.

Thank you to Robin Layton and Kimi Culp for being our amazingly talented partners on *A Letter to My Dog*.

Thank you to the Best Friends Animal Society for your lifesaving work with animals and for being such fantastic partners for this special book. It has been a pleasure to work with your team: Gregory Castle, Amy Wolf, Hillary Hutchens, Michelle Sathe, and Trish Conklin.

Thank you to Tina Constable, Amanda Patten, and the amazing team at Crown Archetype for believing in the power of letters and helping us celebrate the unconditional love we have with our feline friends.

Thank you to Andy Stabile, Ashley Mills, and Katie Zwick from CAA and Steven Grossman and the team at Untitled.

Thank you to all of our contributors and everyone who shared a love letter to their cat. Thank you for letting us into your houses and closets, under your beds, and into your lives.

## Photographers

A very special thank-you to Susan Weingartner and Sharon Hardy, the talented photographers who shot the bulk of the fiesty felines featured in this book.

Susan Weingartner is a photographer and animal rights advocate who has spent over two decades working with various nonprofit organizations helping animals—most recently, Mercy for Animals—including twelve years serving on the voting committee of the prestigious Genesis Awards. She lives in Los Angeles with her son, William, and her three furry feline friends: Michael, Kali, and Aragorn.

Sharon Hardy worked in television production for many years and discovered her passion for photography while volunteering at the Santa Monica Animal Shelter. She now owns her own company, Sweet Potato Pet Photos, and lives in Los Angeles with her husband Eric, one-year-old son, Dexter, and rescue dog, Chubs.

And finally, thank you to all of the other gifted photographers who participated in this book and gave their unique perspective on our featured kitties.

| | |
|---|---|
| Dan Beckmann | Jesse Knott |
| Best Friends Animal Society | Ali Mahdavi |
| Marshall Boprey | Melissa Mahoney |
| Leigh Castelli | Mark Nardecchia |
| Julie Castle | Nikki Ormerod |
| Grace Chon | Savitri Parsons |
| Jason Cohn/Whitehotpix Exclusives/ZUMA Press | Billie Perry |
| Corbis Images | Deborah Ransom and Jason Ransom |
| Angie Cryder | Karl Simone |
| Donna Whitfield DeCosta | Howard Stern |
| Becky Fluke | Kevin White |
| India Hicks | Mary Willard |

**Best Friends**

The *A Letter to My Cat* team supports the outstanding work of Best Friends Animal Society and wishes to express gratitude for all of their support with this project.

To find out more about Best Friends, or to donate, visit: www.bestfriends.org.

## Photography Credits

**Susan Weingartner**: jacket, 2, 6, 14, 16–17, 18–19, 20–21, 33, 40, 43, 44–45, 46–47, 48–49, 53, 54–55, 56–57, 58–59, 62–63, 64–65, 66–67, 72–73, 84–85, 92–93, 94–95, 102–103, 106–107, 110–111, 112–113, 116–117, 120, 128–129, 138, 140–141, 146, 148–149, 156, 159, 161, 162, 163, 165, 166, 167, 168, 169, 170, 171, 172, 173.

**Sharon Hardy:** 8–9, 10–11, 12–13, 26–27, 34–35, 36–37, 38–39, 74–75, 77, 78–79, 80–81, 104, 108–109, 122–123, 136–137, 142, 154–155, 156, 158, 159, 160, 163, 164, 167, 169, 171.

Dan Beckmann: 30, 158; Best Friends Animal Society: 29; Marshall Boprey: 98–99, 166; Leigh Castelli: 50–51, 161; Julie Castle: 158; Jason Cohn/Whitehotpix Exclusives/ZUMA Press: 83, 164; Corbis Images: 172; Angie Cryder: 170; Donna Whitfield DeCosta: 163; Becky Fluke: 124–125, 169; India Hicks: 71; Jesse Knott: 86–87, 164; Ali Mahdavi: 145; Melissa Mahoney: 169; Mark Nardecchia: 68–69, 132, 163, 170; Nikki Ormerod: 119, 169; Savitri Parsons: 91, 164; Tony Perry: 114; Deborah Ransom and Jason Ransom: 61, 162; Stephen Simmons: 126; Karl Simone: 24–25, 158; Howard Stern: 135, 170; Kevin White: 23, 88, 96, 100, 131, 151, 157, 158, 164, 166, 170, 172; Mary Willard: 152, 172.